Drawing **Animals**

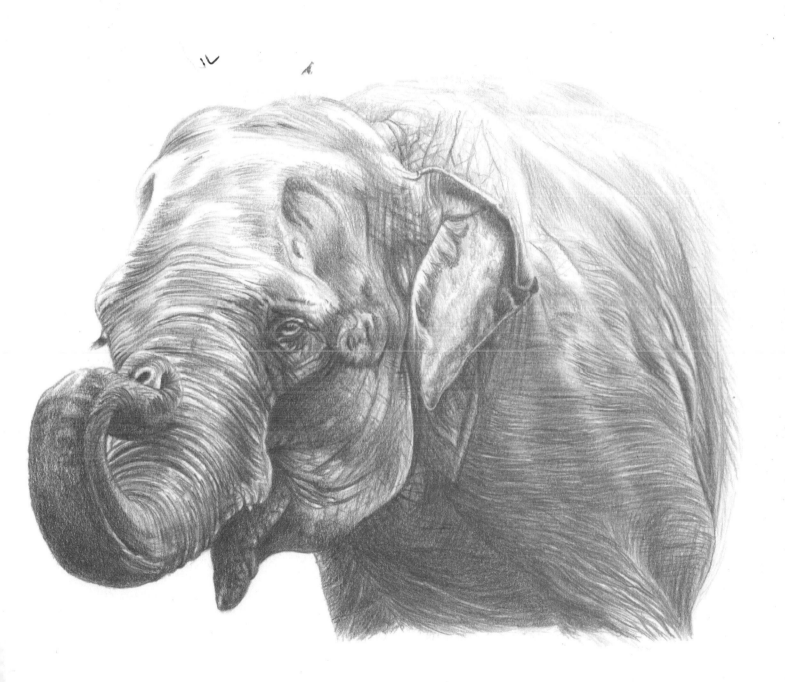

Dedication

To my amazing husband and
four lovely daughters: you
know who you all are...

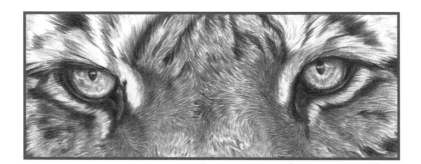

Drawing **Animals**

Lucy Swinburne

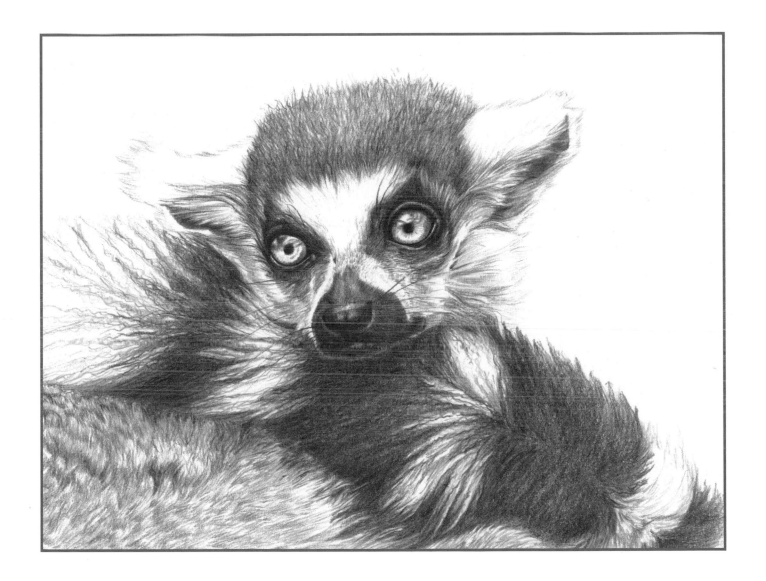

SEARCH PRESS

First published in Great Britain 2013

Search Press Limited
Wellwood, North Farm Road,
Tunbridge Wells, Kent TN2 3DR

Illustrations and text copyright
© Lucy Swinburne 2013

Photographs and design copyright
© Search Press Ltd. 2013

ISBN: 978-1-84448-772-1

The Publishers and author can accept no responsibility for any consequences arising from the information, advice or instructions given in this publication.

Suppliers

If you have difficulty in obtaining any of the materials and equipment mentioned in this book, then please visit the Search Press website for details of suppliers:
www.searchpress.com

You are invited to visit the author's website:
www.lucyswinburne.com

Video tutorials

This book contains a number of short video tutorials that are free to view on the Search Press website: www.searchpress.com

Wherever you see this symbol, you can use a QR code reader or type in the web address printed at the bottom of the image to access the video tutorials.

http://cli.gs/b2i1o41

Printed in Malaysia

Acknowledgements

I would like to take this opportunity to say a special thank you to my whole family for all the tremendous support they have given me while I was writing and illustrating this book.

I need to say a huge thank you to Lynn Whitnall, Director at Paradise Wildlife Park, and say also how grateful I am to her for helping me get closer to her animals. This thank you extends to all the staff at the Park for making me feel so welcome (especially Pia, Josh and Bill) and for all their help in obtaining some of the wonderful wildlife photographs I used for reference throughout the book.

Many thanks are offered as well to the following people for allowing me to use their photographs, when my own efforts failed!

Sue Wallace for the photographs used for A Portrait of Tatra (see page 28), Tiger Stare (see page 2) and Meerkat (see page 34).

Brian for the photograph used for Bearded Dragon (see page 92) courtesy of www.beardeddragon.org.

Finally, a big, big thank you to anyone whose beautiful pets are illustrated in this book.

Front cover
Tatra
40 x 30.5cm (16 x 12in)

Graphite pencil on smooth white card.

Page 1
The Greeting
42 x 30cm (16½ x 11¾in)

Graphite pencil on smooth white card.

Page 2
Tiger Stare
21 x 11cm (8¼ x 4½in)

Graphite pencil on smooth white card.

Page 3
It's a Wrap
30 x 21cm (11¾ x 8¼in)

Graphite pencil on smooth white card.

Opposite
Lone Wolf
72 x 52cm (28¼ x 20½in)

Pastel pencils on smooth grey card.

Contents

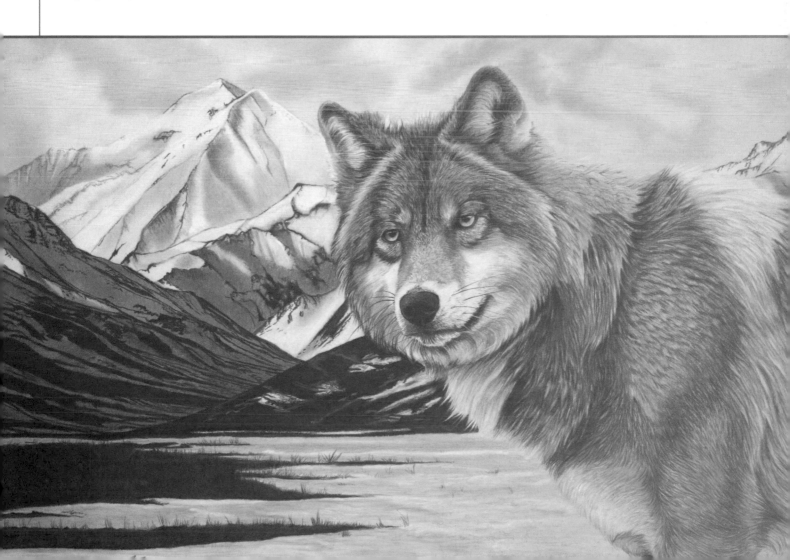

Introduction

In all the years that I have been teaching there is one question that I have been asked many times: 'Can you be taught how to draw?' I am a firm believer in the old adage that you can achieve anything if you want it enough, and this goes for drawing too. If you have the passion and desire to draw then anything is possible. It certainly helps if you are born with the ability to judge perspective and note proportion, but this can be learnt over time through trial and error. When you have drawn something that pleases you, it will have been worth the time and effort.

In this book I have set out to show you how to approach your subjects with as much forethought as possible and to enable you to produce a portrait of which you can be proud. You will learn how to choose your materials, set up your work area, observe your subject, compose it and draw it – everything from start to finish. There are many considerations to make before putting pencil to paper and although I have only scratched the surface in this book, I felt there was no need to overwhelm you this early on!

In my opinion, the most important ingredient required in completing a good drawing is the reference material. In my case that is photographic reference. As I am not a professional photographer and have had to learn on the job, all I can say is thank goodness for digital cameras! Now I can see immediately if I have taken enough decent images to work from. I have also learnt to take close-ups of features like eyes and noses, to help later on when I am drawing these details. Too often I have returned home, keen to start and then realised my subject is missing a tail that was tucked behind, or to find that I could have benefited from another view of my subject from a different angle. You do not need an expensive camera but if your particular speciality is animal portraits, a decent zoom lens is going to further your cause. With animal photography, patience is the keyword. Watching and waiting will not only improve your observation skills but enable you to capture that special shot.

As a complete beginner or even an amateur, the hardest part of drawing is the actual drawing. If you are not blessed with the talent to draw freehand (and not many people are, even professional artists), do not fear, you will learn all about the methods available for transferring your image to paper within this book. You will also learn how to create different textures and how to complete a drawing by following the step-by-step examples provided.

As a teacher, the most satisfying element of passing on my knowledge is seeing the enthusiasm and understanding grow in my students. The discovery that I could actually enrich other people's lives simply by sharing my own love of drawing was a fantastic realisation.

It is with this thought that I will leave you to study my book at your leisure and hope that you find it informative and inspiring.

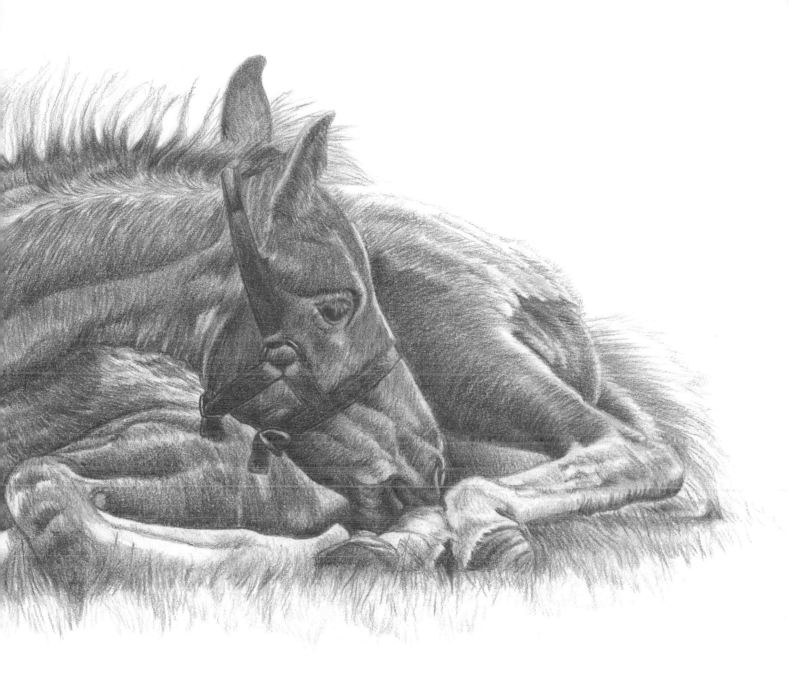

That Awkward Bit

30 x 21cm (11¾ x 8½in)

Graphite pencil on smooth white card.

This leggy young foal lives near my home. She has yet to shed her coat of baby hair, which adds to the appeal of the drawing.

The history of drawing animals

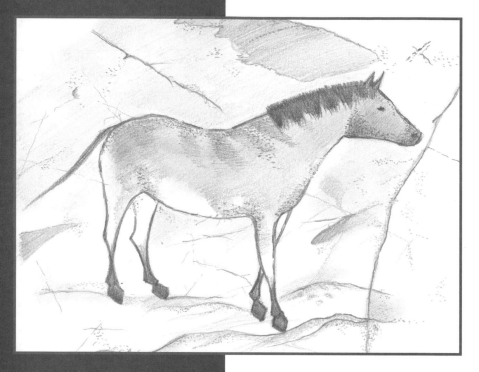

Horse, in the style of prehistoric cave paintings

28 x 21cm (11 x 8¼in)

Graphite pencil on smooth white card.

It is not known when people first began drawing animals or indeed who was the first person to make their mark. The Palaeolithic era saw the development of tools from stone, and the cave paintings of this era are undoubtedly the source of animal drawing. The oldest of these date from 33,000BC and it is likely that the animals in these cave drawings were painted as a type of ritual related to hunting. Others suggest that they were painted as part of religious ceremonies or as a form of calendar. One view is that early man painted these animals as a record of the beasts that they had killed, as no evidence would have remained once they had been consumed. The drawings became a record of each hunter's achievements. Most interestingly, it is very obvious that these drawings were public and could be viewed by anyone.

These cave paintings were always 'floating' with no ground or horizon line and lacked depth but had a high level of detail. This showed that the artists had a very close relationship with the animals they were drawing. Many ancient examples of cave paintings have been found throughout Europe and in particular in France. The oldest known cave paintings are of big cats and rhinoceroses in the Chauvet-Pont-d'Arc Cave in the Ardèche region. The discovery of shaped stone and sharpened bones made it very likely that the artists painting these images were in fact the hunters. The pigments they used to create the colours were very primitive – burnt wood or chalk mixed with earth, for example – but they were still very effective.

Animals have appeared in the artwork of numerous cultures throughout history. The ancient Egyptians painted many of their gods with the heads of animals and tribal art from all over the world includes images combining animal and human features. During the

Middle Ages, European artists embellished their manuscripts with amazing mythical animals; and during the fourteenth century horses were commonly depicted with exaggerated masculine characteristics, including muscular thighs, stocky bodies and short tails.

Leonardo da Vinci (1452–1519AD) the Italian Renaissance genius, was one of the first artists to create studies of his animal subjects and produce preliminary drawings. There are many examples of this, whether it was horse head studies, or life studies of cats and dogs.

Albrecht Dürer (1471–1528AD), one of da Vinci's contemporaries, was the first modern artist to see animals as worthy subjects for paintings. This happened during a time when many explorers were returning from distant lands with plants and new animal species, and interest in the natural world was being sparked. Dürer used pen and ink to create very detailed studies.

One example, entitled *A Rhinoceros* (1515AD), was created from a sketch supplied by an unknown artist. Since Dürer never actually saw the animal first-hand, there were anatomical errors. In constrast, he also painted a watercolour and gouache painting of a young hare in 1502AD. The result was an amazingly realistic hare, especially considering it was most likely created from a stuffed animal as opposed to drawing from life.

Following renewed interest in Dürer after his death, the 'Dürer Renaissance' began in Nuremburg. An artist called Hans Hoffman (1530–1591/2AD) became well known for his portraits and studies of plants and animals based on Dürer's work. He went on to achieve a sense of realism superior to that of Dürer's own work.

Cat studies, in the style of da Vinci
30 x 42cm (11¾ x 16½in)
Graphite pencil on smooth white card.

As time moved on, interest in animal art continued to grow and another great painter emerged. George Stubbs (1724–1806AD) was probably the greatest equestrian painter of all time, but was never fully appreciated during his lifetime. His paintings of horses and foals were depicted in fine detail because he knew their anatomy so well. Unfortunately, equestrian and sporting life paintings were frowned upon by the critics and his work did not receive the credit it deserved until the twentieth century. His unusual technique involved first painting the horses and then adding the background at the end. Stubbs considered the background to be the least important part of a painting, and he produced one famous painting of horses with no background, *Mares and Foals without a Background*, in 1762AD. Many people consider this to be his best work. Following on from Stubbs, many Victorian artists began painting intimate portraits of their domestic pets and livestock.

In the late nineteenth to early twentieth centuries, an Expressionist artist called Franz Marc took things a stage further by painting abstract animals. One particular oil painting called *Tiger* (1912AD) showed the tiger and background completely made up of geometric shapes. The tiger stands out from the background as it is produced in strong yellow and black shapes to depict the animal's markings.

Cecil Aldin was another artist working at this time. He began his career as an illustrator for journals and magazines in 1890AD. Aldin was a keen sportsman and many of his works depicted 'the chase'. One of his most famous works was *Master of Hounds*. He also produced a book of pastel drawings which included a selection of sketches of his own dogs on his sofa.

Pablo Picasso also had an influence on the art of drawing animals. During December 1945AD, he produced eleven different developments of a lithograph, called *Bull*. He began with a drawing of a bull rendered in detail and then began to strip the picture down stage by stage; first into a mythical creature, then showing the anatomy in a defined way, right through to simplifying the structure, creating line drawings and almost totally recreating his first drawing. The finished picture was rendered in Picasso's familar style, with the bull stylised and shown in an abstract form.

Of course, artists painted a huge range of animal genres during the twentieth century and even created a few of their own. Wildlife art and animal portraiture is now very collectible and has a great following. It is of course my own favourite subject.

Jack Russell, in the style of Cecil Aldin
30 x 21cm (11¾ x 8¼in)
Graphite pencil on smooth white card.

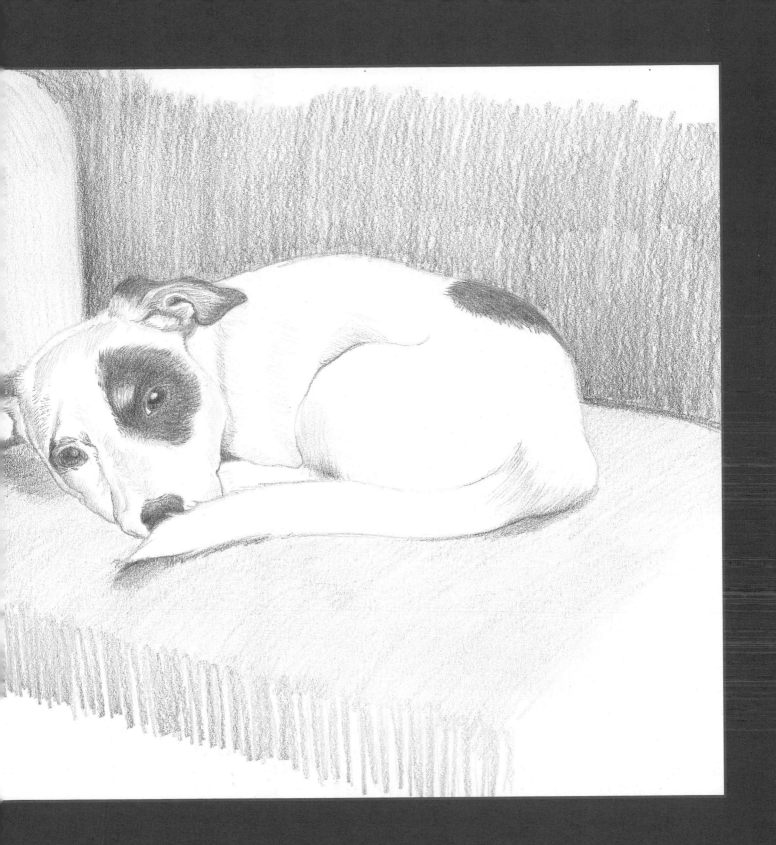

Materials

In this chapter, I will explain the different media available to you to produce your drawings and show you the different marks each type make in order to give you an idea of how they work. Next I will tell you about the different types of surface material available and show you the effects of drawing on some of them. You should then be ready to begin to plan your picture.

GRAPHITE PENCILS

Everyone has used a graphite pencil and they are probably the first medium you would think of using to produce a drawing or sketch. There are many different types, including technical pencils (hard), sketching pencils (medium) and whole graphite sticks (soft). All of these are easily sharpened with pencil sharpeners and are easy enough to erase if a mistake is made, as long as limited pressure has been applied to the paper or card. Graphite pencils can break if dropped on to a hard surface, so take care of them when they are out of the box.

Pencils are graded. Those marked H are harder and they typically range between H and 4H. The higher the number, the harder the graphite. The softer range of pencils are marked B, and they generally range from HB to 9B. The higher the number, the softer the graphite.

Typical sketching or technical pencils are light and wooden-cased, and range from HB up to 6B. The heavier graphite sticks come in a wider range of grades, from HB to 9B. Graphite sticks wear down more quickly and are very soft and grainy. If you want crisp, clean lines or edges to your drawings, the more typical wooden pencils would be better suited to the task.

When you first use a graphite pencil or stick, the temptation is to use one grade (a 2B, for instance), to complete a whole drawing. Certainly you can use only a single grade and alter the pressure of the pencil to create darker tones as you progress, but a much more professional approach is to use several grades, building up from light to dark. This approach requires you to begin with a light pencil, such as a 2H, to lay down the base for the different tones to follow. You then 'top up' by using a 2B or 4B pencil to darken further. These two grades of pencil may be enough on their own (depending on how dark you need to go), but there is the option of using a 6B and up for deeper shades.

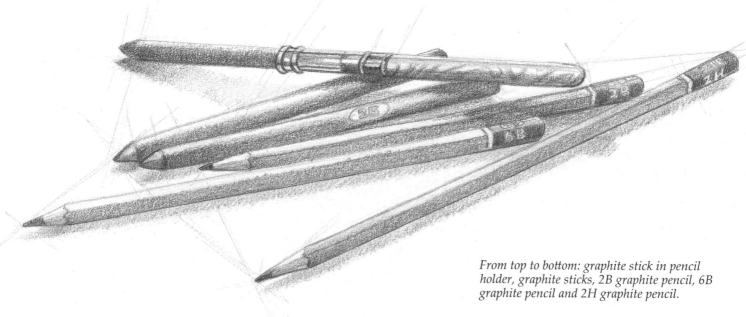

From top to bottom: graphite stick in pencil holder, graphite sticks, 2B graphite pencil, 6B graphite pencil and 2H graphite pencil.

Graphite pencil techniques

On this page are some simple shapes demonstrating shading and textural techniques using graphite pencils. Drawing with graphite pencils can be extremely rewarding but plenty of practice is required to help you discover your own unique style.

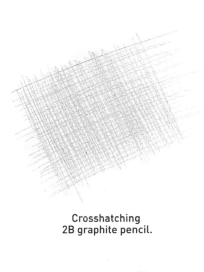

Crosshatching
2B graphite pencil.

Graduated shading
2H, 2B and 4B graphite pencils.

Stippling
6B graphite pencil.

Graduated shading blended with tortillon
(see page 17)
2H, 2B and 4B graphite pencils.

Circular shading
2H and 2B graphite pencils.

Scribbling
6B graphite pencil.

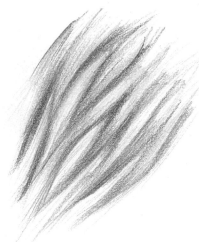

Negative shading
2H, 2B and 4B graphite pencils.

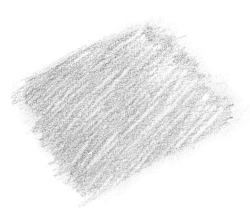

Battery eraser used over the top of shading work made with 2H, 2B and 4B graphite pencils. The pencil work was blended with a clean finger before the eraser was used.

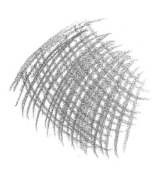

Curved crosshatching
6B graphite pencil.

PASTEL, CARBON AND CHARCOAL PENCILS

These media produce drawings that are loose in style, with less detail than graphite pencils. This is great, especially if you want to work on a large scale. As you work with any of these media you need to take care as you work; you will need to use some rough paper to rest your hand on to prevent smudging.

Pastel pencils

Pastel pencils are extremely versatile and different makes will offer subtle differences in blending, application and ease of sharpening. Most pastel pencils will fit in a standard pencil sharpener, but some makes are too wide to fit in a conventional sharpener. For these, a point can be maintained by using a scalpel or sandpaper block. I do not recommend battery-operated sharpeners for pastel pencils as they are too abrasive.

The main difference between pastel pencils and carbon and charcoal pencils; is that it is much easier to establish finer detail with pastel pencils, especially in small areas.

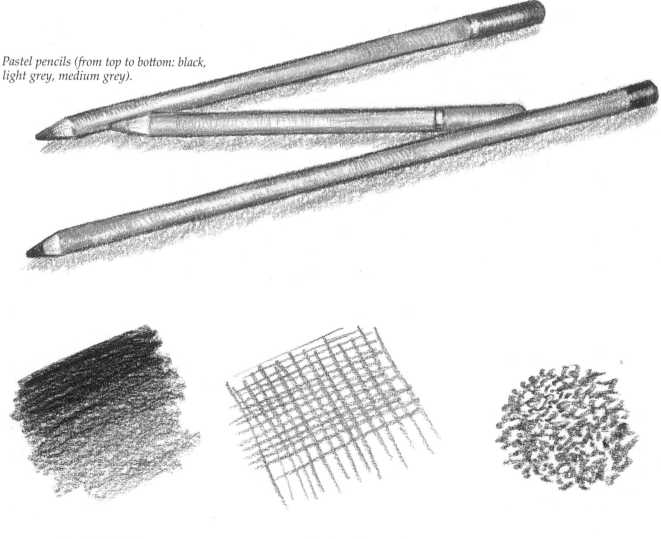

Pastel pencils (from top to bottom: black, light grey, medium grey).

Graduated shading
Pastel pencil.

Crosshatching
Pastel pencil.

Stippling
Pastel pencil.

Carbon and charcoal pencils

If you want to produce quick sketches from life, or preliminary sketches for a main drawing, carbon or charcoal pencils/sticks are an excellent medium to do this with. They are a good medium for producing fine sketches of animals and just as great for shading in large background areas.

If you intend to use a battery eraser with these media, be aware that the particles removed by the rubber tip will spray out and adhere themselves to other areas of the drawing – and not necessarily where you want them! Where possible, the best way to remove these unwanted particles is to gently blow them away with your mouth. If they resist, you can brush them away gently with a soft make-up brush.

Tip

Carbon pencils can be fairly messy, so I recommend that you work at quite an acute angle, to allow loose particles to fall away from your drawing area.

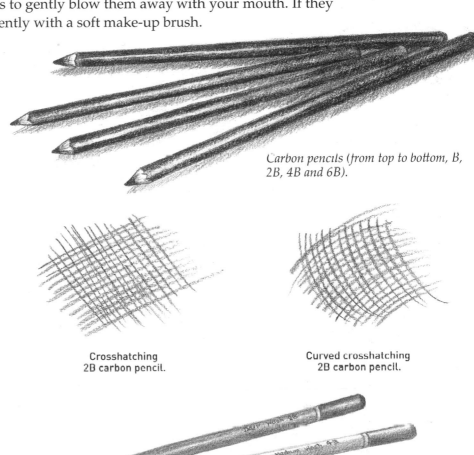

Carbon pencils (from top to bottom, B, 2B, 4B and 6B).

Graduated shading
2B carbon pencil.

Crosshatching
2B carbon pencil.

Curved crosshatching
2B carbon pencil.

Charcoal and sketching pencils (from top to bottom: 8B, 4B and HB), plus charcoal sticks.

Graduated shading
Charcoal stick.

Crosshatching
Charcoal stick.

Stippling
Charcoal stick.

PENS

Ink and ballpoint pens are traditionally used in conjunction with watercolour washes for animal drawing, the watercolour being used to fill in the background behind the ink pen drawing or sketch. When tackling architectural drawings, technical and ballpoint pens really come into their own. However, when drawing any subject matter with them, you have to be confident with your strokes.

Before you start, you need to understand that your completed image will contain all your construction lines and any errors you made along the way. This can, however, add interest and movement to the picture. Life drawings, for instance, can look quite spectacular when rendered in ballpoint pen.

Ink pens are perfect for any type of study or drawing including animals, landscapes and structures. If you intend to use any type of pen, make sure you experiment with different types of paper or card, in smooth and with differently textured surfaces.

As you are working, you must use a piece of rough paper to rest your hand on. Just like ink pens, ballpoint pens can take a short while to dry – smudges are easily created with one wrong move, but not so easily corrected!

A selection of refillable technical ink pens. Three fineline pens ranging from 0.35mm to 0.7mm, and two ballpoint pens.

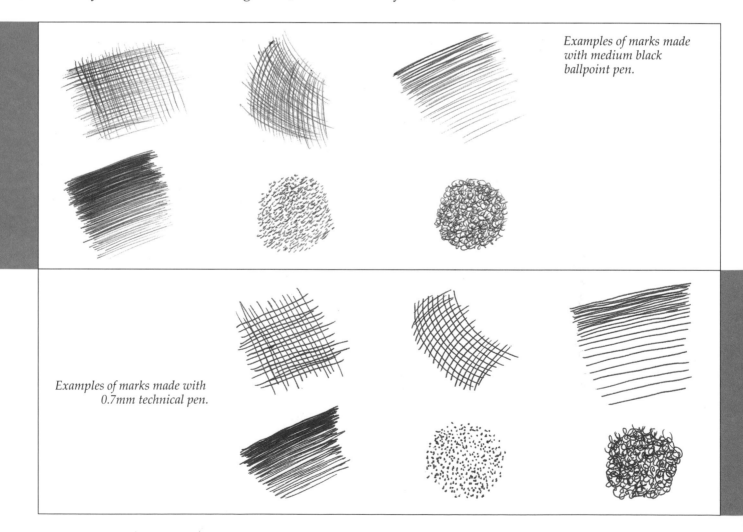

Examples of marks made with medium black ballpoint pen.

Examples of marks made with 0.7mm technical pen.

OTHER MATERIALS

There are lots of other materials you can use, some of which are compulsory and others that are not. Trial and error will tell you whether you need them.

Masking tape is a compulsory item for securing your card to your working surface (whether it is a desk or an MDF board). The best rolls I find are bought from DIY stores, so there is no need to splash out on the most expensive types in art shops. Another compulsory item is your **putty eraser**, the best type of which are kneadable. This simply means that you can shape it to lift off small areas of pencil or roll it into a ball for larger areas. It is also self-cleaning. When it is dirty just fold the soiled outer edges in towards the centre and hey presto, a clean eraser!

Whether you use a **scalpel**, an **electric pencil sharpener** or a **manual pencil sharpener** is a matter of personal choice. Note that electric sharpeners can be too abrasive for many pastel or carbon pencils which break easily. Whichever you choose, I suggest that you use a small pot (with a lid) to catch your sharpenings as you work, to save trips to the wastepaper basket once you have found a comfortable working position.

Tortillons, or **blending sticks**, are again something you need to try first, to see if they suit your technique. An **acetate grid** is also not something everyone will want to use but later on in the book I describe in detail how to use the grid method for transferring images, should you wish to try. You will need a **ruler** for this too.

Finally, I recommend a **soft brush** of some kind, such as a large make-up brush, to dust off your drawing and free it of any pencil shavings or eraser finings as you work.

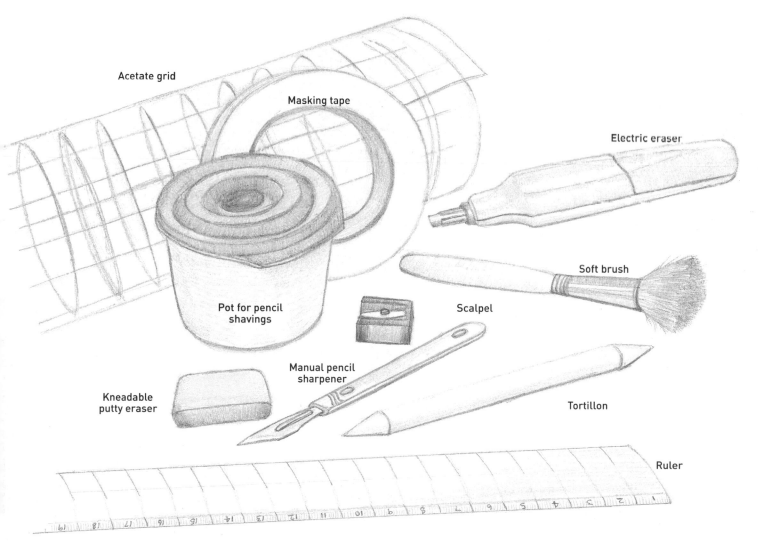

Acetate grid

Masking tape

Electric eraser

Soft brush

Pot for pencil shavings

Scalpel

Manual pencil sharpener

Kneadable putty eraser

Tortillon

Ruler

SURFACES

The sky really is the limit when it comes to surfaces on which to bring your drawing to life. It really boils down to experimenting, and remember that nothing is right or wrong; just find what works for you.

When I first started drawing seriously I imagined that all pencil drawings were produced on cartridge paper – a natural assumption, as it was the most common paper supplied for us at school. The more practised I became, the more I wanted to explore the effects graphite pencils had on different surfaces. I loved using rough watercolour paper, as it added texture to my work. More recently I got to experiment on stretched canvas due to an unusual request from a client booking a commission (the example I produced is below). Finally, I decided that smooth card suited my personal style after having tried mount boards and pastel cards. This is now my preferred surface material. It works extremely well and I always end up with a very clean and finely detailed drawing or painting.

As an aspiring artist you will discover other artists, past and present, that you may want to emulate or even surpass. Through studying their work and style, you will come to realise just what sort of artwork you aspire to produce and then you really have something to aim for!

I have decided to show you three different surface types, each with the same drawing produced on them.

Stretched canvas

This surface is extremely rough, with many bumps and dips, making it very difficult to control the pencil as you are working. It does respond quite well to a kneadable putty eraser, but this should be used mainly for lifting off unwanted pencil. Do not rub as this will smudge the graphite and leave a dirty mark. Unfortunately, it is quite hard to get the depth required on canvas as the surface begins to resist the graphite after a while.

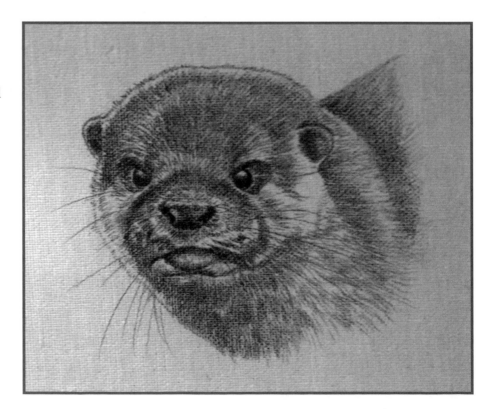

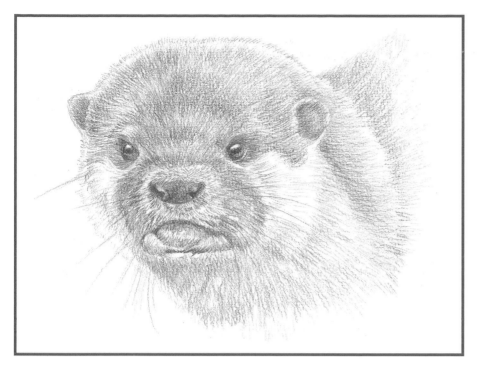

Rough watercolour paper

Although not as textured as the canvas, this cream-coloured rough watercolour paper still has quite a rough surface. This paper takes pencil more readily than canvas and more detail can be achieved by gradually building up. Again, a putty eraser can be used to lift off pencil but an ordinary eraser will also work, as long as it is clean and used gently.

Smooth card

This third study has been produced on a smooth white card. All of the otter studies on these pages were completed in the same way, but you can see how much more detail has been maintained and how crisp the lines are on card compared with the other surfaces.

The outline was first sketched with a 2H pencil, which was then used to create the first layer of fur and an undercoat on the eyes. Next, a 2B pencil was used to deepen the fur layers and darken the eyes, ears and mouth. Finally a sharp 4B pencil was used to give more depth all over. This was done gently, in gradual layers. Pressing too hard with a 4B pencil will result in a shine and the inability to deepen that area further. Working gradually may seem slow, but the results will be much more rewarding.

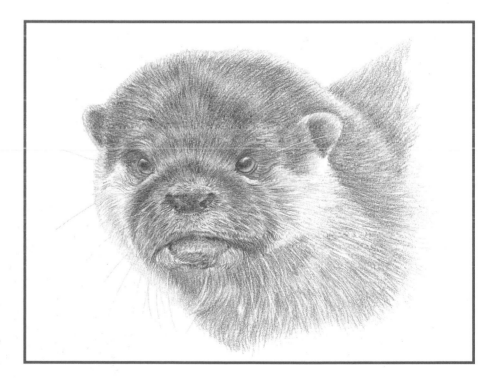

How to start

GATHERING YOUR REFERENCE

There are a few ways of putting together reference material but the easiest method is taking digital photographs. Certainly, you can use images from books to help with your drawing and also use photographs in books as reference only. However, nowadays animal photography is big business and you have to be very mindful of copyright when it comes to using other photographers' images or photographs from the internet. It is best to use your own photographs wherever possible, or you can try contacting amateur animal photographers to ask if you can use any of their images. Failing that, it will require a little bit of effort on your part and a few visits to your local zoo or wildlife park, to take your own pictures.

Digital cameras

Thank goodness for digital photography! Once upon a time I would eagerly take my films to be processed with high hopes, only to have them dashed when I collected my prints. Somehow they never looked as I had imagined, and I am sure I am not alone in that regard. Well, be disappointed no more. The immediacy of digital photography could not be better for the amateur photographer or artist. You can tell straight away whether you have taken 'the shot' or not and you can simply take more if the answer is 'not'.

Illustration of my SLR camera and a digital image taken with it.

I had to wait a while until I could afford an SLR (Single-Lens Reflex) camera but this type of camera is far better than an automatic, as there is no shutter delay when you are trying to take a picture of a moving subject. It is very frustrating to keep missing the perfect shot, and an SLR camera it is the best piece of equipment to ensure you capture it.

Most of these cameras come with a short distance lens only which is typically 18–55mm. I own a Canon 400D which is an exceptional starter camera and very user-friendly. If you want to take close up portrait shots you will need a basic zoom lens. A 70–300mm lens is the ideal one. It is fairly inexpensive, lightweight and does not increase camera shake if you have a steady hand or use a tripod.

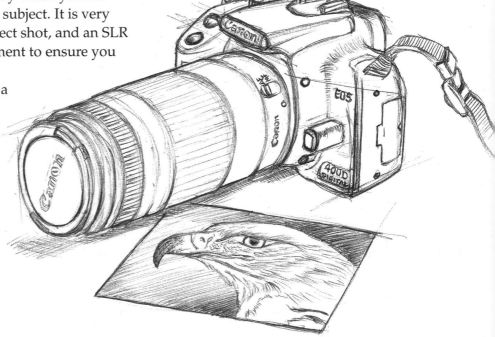

PREPARING YOUR WORKSTATION

The best way to start is to be fully prepared. I can guarantee I will just get comfortable and then find I am missing something I need to start my drawing! Invariably, it will not be the last time I have to extricate myself from my desk and go in search of an essential tool – so be sure to be ready from the start.

I have invested in office-style storage to help me become more organised and enable myself to put away any completed work in a safe place. This equipment need not be expensive, and the best place to look for second-hand items is online. I have a set of drawers and a small cabinet that looks like a mini wardrobe, with shelving inside.

It is not imperative to have an art desk. When I first started, I did not own a desk and so I used canvas boards as my surface and taped my paper or card to the untextured reverse side. Another cheap option is to cut some MDF board to size and use that as your board to lean upon.

It is always better to work at an angle, as you begin to lose a sense of proportion and perspective by working flat. The easiest way to do this is to sit at a table and rest the top of the board on the table edge. Place the bottom of the MDF in your lap and you have an angled working position. It is almost impossible to make this angle too acute but do make sure you are comfortable.

Before you begin, you need to make sure you have all the pencils you require, your eraser, sharpener and pot for sharpening's, reference pictures, masking tape and any other materials to hand. Use some masking tape to attach the corners of your card or paper to the board, to prevent any movement.

It is important to keep your paper or card clean as you work, so use a piece of paper to rest the side of your hand on as you move across the card, to prevent smudging your work.

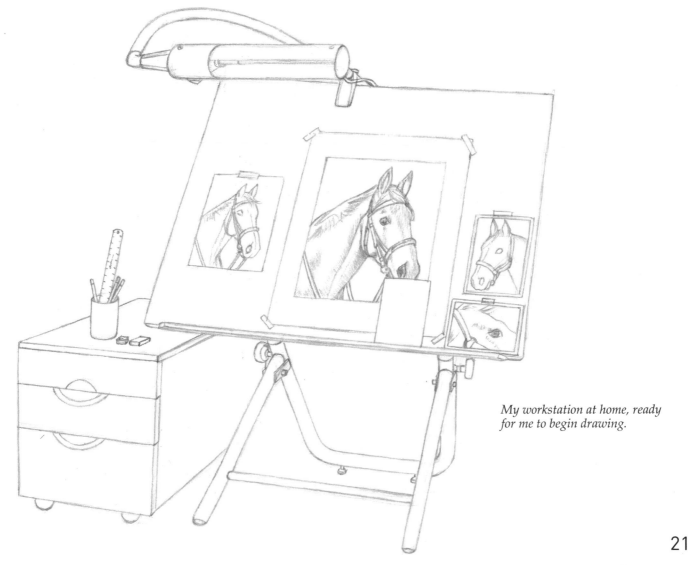

My workstation at home, ready for me to begin drawing.

PLANNING YOUR PICTURE

Taking reference pictures

If you are lucky enough to be able to meet your subject and take your own photographs, you need to make sure that you have enough good quality reference shots. The same principles apply to being supplied with images from which to work, but this method means it is slightly harder to get exactly what you want.

Regardless of the method you use, your aim should be to try to build up a three-dimensional image of your subject by correctly selecting reference images.

As an amateur you often have to learn by your mistakes, and I am speaking from experience. I would often get back home after taking photographs of my subject and realise that none of my pictures contained the animal's tail for instance, or a good clear eye or nose shot! If you are taking the photographs yourself, here are a few tips to remember:

- Try to take any photographs outside in natural light.

- If the animal is excited, wait patiently for them to settle down before beginning.

- Take treats or squeaky toys where appropriate to get the animal's full attention and focus on you.

- Ensure that you take full body shots and close-up head shots as well.

Planning the composition

If you have considered your reference photographs carefully, this part should be fairly straightforward. When you look through your images, the best thing to do is to begin shortlisting them for preference. You will then be better placed to select the best photograph from which to work, having eliminated the others.

As an example I am using a horse to show you the reference material that will help me complete this particular portrait and the other images that will provide me with further information as I begin to work. The next step is to draw out your animal's outline on to your chosen surface.

TRANSFERRING THE IMAGE TO PAPER

The grid method of transferring your image on to your surface is used by artists all over the world and is not to be considered cheating: you will require skill to transfer the image correctly. If you are like me, you will be so keen to start your new portrait or drawing that if any part of the planning stage can be eliminated you will jump at the chance. With this in mind I am going to explain the grid method assuming that you are beginning with your photographic reference the correct size and that no enlargement is required.

When I first started using the grid method, I drew a grid over my reference picture and then a corresponding grid on my paper. There is nothing wrong with this but it does ruin your reference picture. Instead I recommend creating a permanent grid that you can reuse. This is the easiest way to transfer your selected image to your paper or other surface without damaging your reference.

The majority of the portraits I produce are smaller than 40 x 60cm (15¾ x 23½in), with most around 30 x 40cm (11¾ x 15¾in). I now work from photocopies that are the exact size I wish my finished portrait to be. This eliminates the need for enlarging by grid method which can be complicated.

YOU WILL NEED:

- Piece of transparent film or acetate, 30 x 40cm (11¾in x 15¾in)
- Slim-tipped black permanent marker pen
- 60cm (23½in) ruler
- A set square
- A solid surface to work on

Creating a permanent grid

1 Use the set square and ruler to draw a 30 x 40cm (11¾ x 15¾in) rectangle on your film or acetate to give you a shape to work within.

2 Starting in the top right-hand corner of your acetate (A), use the pen to mark in 2cm (¾in) increments towards the bottom right-hand corner of the rectangle (B).

3 Next, move back up to the top right-hand corner and mark in increments of 2cm (¾in) across to the top left-hand corner (D).

4 Now, mark down from the top left-hand corner (D) in 2cm (¾in) increments to the bottom left-hand corner (C).

5 Go back to the bottom right-hand corner (B) and mark back across to the bottom left-hand corner (C) in 2cm (¾in) increments.

6 Finally, use the ruler and marker pen to carefully join up all your marks into horizontal and vertical lines. You will now have a permanent grid with which you can overlay your reference picture.

Tip

These instructions are for a 30 x 40cm (11¾in x 15¾in) grid of 2cm (¾in) squares, but you can easily alter the size for larger pictures, or the size of the grid for finer or broader detail.

Preparing your paper or other surface

When drawing your grid on your paper to transfer your image, the key thing to remember is use a hard pencil (ideally a 2H) and to use very little pressure from your hand. Remember that you will want to erase these gridlines when you have finished drawing out your image. Any pressure on the pencil will make this very difficult to achieve. If you use a soft pencil and you try to use an eraser to erase the lines, the pencil is more likely to smudge and leave a dirty mark that you will not be able to remove.

In this example I am using smooth white card to work on. You need to count the amount of horizontal and vertical squares on your reference picture grid to make sure you have the same number on your permanent grid and your paper grid.

1 Establish a rectangle of the correct size on your surface; in this example, 30 x 40cm (11¾ x 15¾in).

2 Draw your grid in the same way as you did for your permanent grid but using the 2H pencil.

3 You can now attach your grid to the front of your photocopy using some masking tape. Now you will have your film grid taped gently over your reference photocopy and a matching grid on your paper or card.

Tip

Position your film grid so that details such as eyes are on the line between two squares rather than dead centre within a single square. It is much easier to plot the position of details like this between squares.

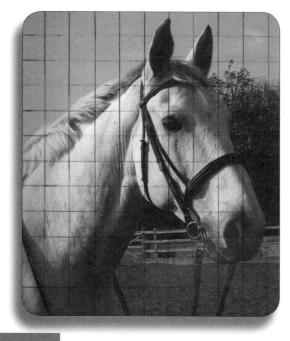

Transposing the image

The aim now is to transfer the information from your film grid on to your paper, square by square. The best way to start is to use your grid to plot the highest point of the animal, which in this case is the horse's right ear. Count how many squares from the top of the grid and how many squares in from the right-hand side of the film grid the ear in placed. Plot these corresponding points on your card grid so you know where to begin. Double check your measurements by counting the number of squares down from the tip of the ear – or where you want the portrait to end – to ensure you have enough room on your card and that the portrait appears in the right place on there too. Ideally there should be some empty space above the ears or the portrait will look too cramped. Check also that there is the correct number of squares widthways on your card.

1 Beginning with the square containing the tip of the right ear, copy what you see in the film grid square into the corresponding square on the card.

2 Work down and around the outline of the horse first. As you work, ensure that no squares have been missed out by checking the number of squares on the grid between features such as the ears and the nose, or the nose and the back of the neck.

3 Eventually you will end up with an outline of the horse on the card. After checking that you have transferred all of the image across, gently erase all of your gridlines with a clean eraser.

Tip

The best way to measure within each square as you are working is to picture your square split into quarters. This helps to break up the space and enables you to copy the information more accurately. If this helps but it is too complicated to do in your head, try picking a section of your grid and divide some of the squares into quarters with a pencil. Another way is to simply have another smaller grid made up of 1cm (⅜in) squares to help with important details such as the eyes.

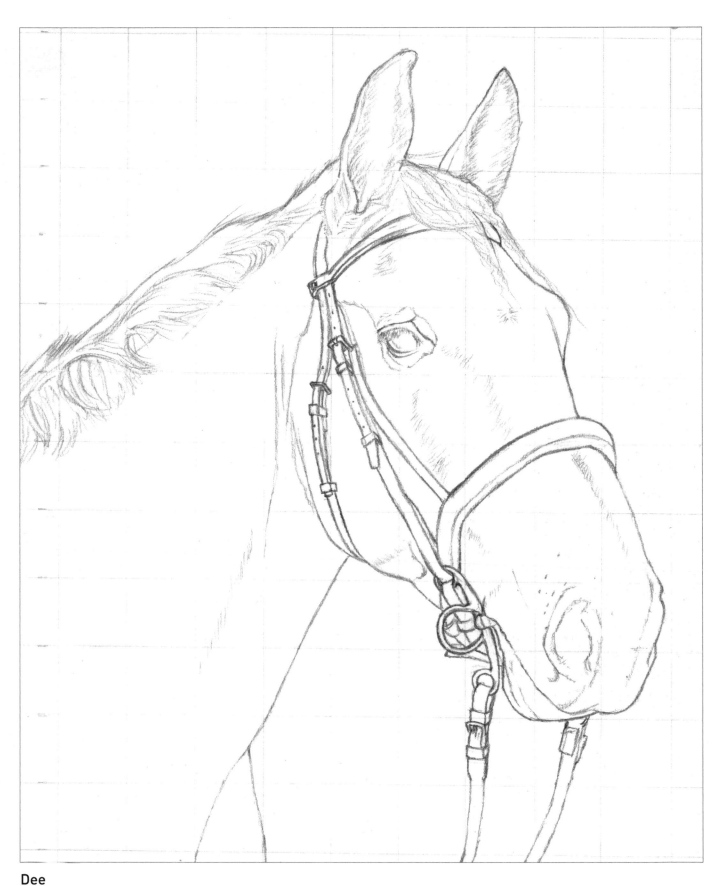

Dee

30 x 40cm (11¾ x 15¾in).

The outline completed and ready to shade.

WORKING WITH REFERENCE PICTURES

Drawing by eye is often considered the hardest thing to do. If you pass a pencil to someone, a common response will be that they can not draw, even before they try! To successfully draw by eye, whether it is copying from a picture or drawing from life, you must be competent at two things, perspective and proportion. Without these ingredients your drawing will not be correct.

To draw well, it is critical to ensure that the photographic reference from which you are sketching or drawing is the best it can be. Your drawing will only be as good as your reference material, and there are many ways of taking photographs of a subject; not all of them are good. These pages show you some examples of good and bad perspective and proportion for you to compare and contrast.

Perspective

The photograph of the wolf on the left would not make a good reference picture. The angle of the photograph makes the wolf appear stumpy-legged and the size of her head has been exaggerated. If you tried to copy this image, it would be very hard to draw the angle of her legs, and this is something to consider when choosing your reference photographs. Although this particular wolf, Tatra, is relatively short and compact compared with other wolves, this is not a good photograph of her.

The second picture (right) is another one of Tatra. This time the picture has been taken slightly above and side-on to her. It is more flattering, showing the length of her body and there is no foreshortening of her front legs. Her head is also in proportion to her body and the whole effect is much more pleasing to the eye.

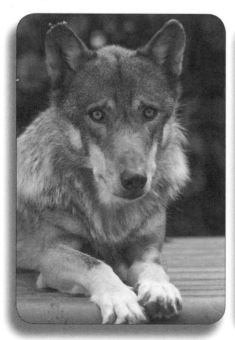
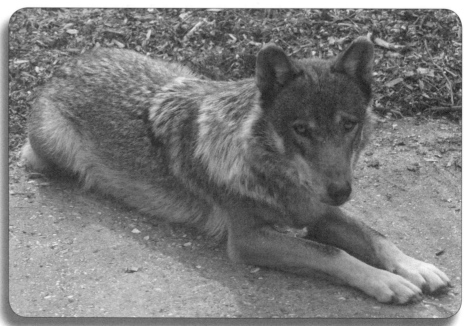

Proportion

This is the other component of a good freehand drawing. To the right is a photograph of Dee, looking stunning but not in proportion. The position I was standing in when I took the photograph was definitely too close and it appears as though I am nearly as tall as him. The effect has shortened his legs so that they are no longer in proportion with his body. His head is pushed forward and as this is the closest body part to the camera, it now looks too large in comparison to the rest of him. As he is positioned head-on to me, there is nothing for the eye to gauge the size of his head against and so the result is not good.

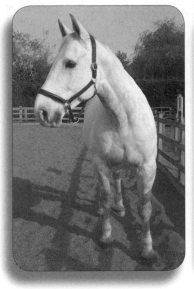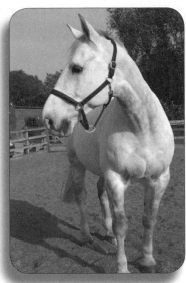

The second picture (far right) is again of Dee, and in a similar pose. However, this time his whole body is at an angle to me, giving the image more perspective against which he can be measured. His head is turned side-on and this makes his neck look longer. This angle has not foreshortened his legs and it is much easier to see how tall he is in comparison with his width. In the first photograph the back half of his body is obscured, but in the second even his tail is in view. All in all, this is a much better picture from which to work.

Observation

Being observant is something we all like to think we are good at, and it is easy to convince yourself that you will be able to remember specific details when you are back at your desk. However, observation for drawing is more complex.

I am very careful to observe the animals' mannerisms and personality traits but as much as I like to think I can commit these details to memory, it rarely works out that way. I take many hundreds of photographs to enable me to complete detailed commissions of all sorts of animals.

My reference photographs become my map of that particular animal. There are always particular markings or blemishes that are unique to them and must be replicated in the portrait to ensure that the portrait is recognisably that specific animal.

Good observation includes understanding fur direction, muscle tone and bone structure. This may sound overwhelming but it is really just about using your eye to study things more closely, and more carefully.

Tips

- Practise by drawing sleeping pets.
- Start with rough lines to complete the outline.
- Make sure you are happy with your outline before you get distracted by details.
- As you sketch keep measuring each part of the body against other body parts to maintain the correct proportions.
- Work on an angled surface so you maintain your perspective as you work.
- Drawing in ballpoint or ink pen can be good fun and leaving in your plot lines can add interest to your finished drawing.
- Finally, practice makes perfect. It really is the only way to improve your freehand drawing.

Wolf

The wolf is my favourite animal, as anyone who knows me will be well aware! No dog lover can help but be moved by their grace and beauty. A much maligned and misunderstood species, wolves are shy, retiring and hard to find. Thankfully there are many people who have dedicated their lives to studying this amazing pack animal, and after many years of persecuting them, we are finally beginning to give wolves the respect they deserve.

The model for this project is a wolf called Tatra, one of two sister wolves at Paradise Park in Hertfordshire, UK. This is a photograph of her in full winter coat, when she looks her most stunning.

MATERIALS

Smooth white card, 42 x 30cm (16½ x 11¾in)
2H, HB, 2B and 6B graphite pencils
3B graphite stick
Pencil sharpener
Putty eraser
Embroidery or darning needle
Rough paper

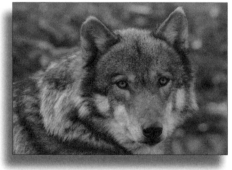

1 Outline Create a grid on your card using a 2H pencil very softly so you can erase the gridlines easily when you no longer need them (see pages 23–24 for more information), and transfer the outline to the card.

Indenting hairs To ensure you are left with white hairs on your wolf (for instance her lips, ears and cheek fur), use an embroidery needle to score the short or long hairs on to your outline, starting from the root and working outwards to the tip. Even though these are mainly short strokes it is a good idea to practise first on some spare card so that you are fairly confident before you start. When you first shade over this area, use a soft 2B pencil to shade across the indented area being careful not to let the pencil point fall into the scored lines as removing this will be hard. Your indented whiskers will now stand out from your background as you work.

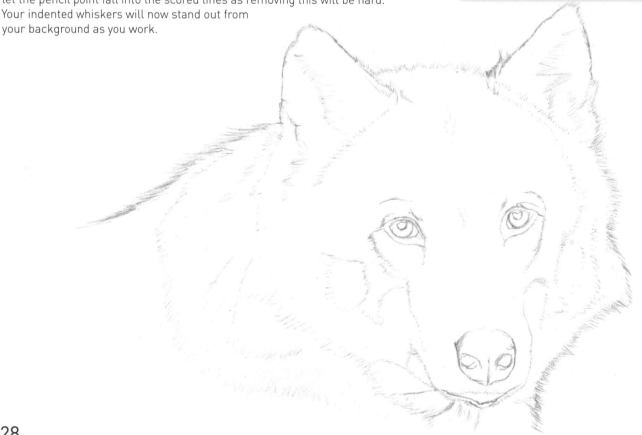

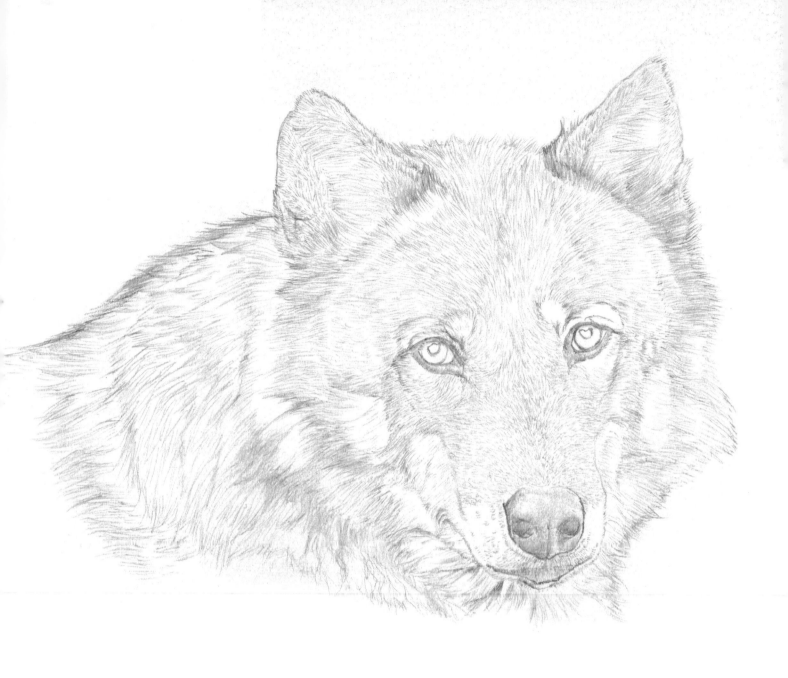

2 **Fur and features** Where to start is a personal choice but the eye area is generally good as the hair direction is very obvious. Use a sharp 2H pencil to add the first layer of fur to the wolf's coat. Take time to emulate the fur direction as it needs to be correct to show off her bone structure to full effect. Gently fill in the bottom eyelid and dark inner eye (around the iris) and the nose. For the nose use a blunt point and shade in small circular movements to create texture.

3 Developing the fur and features Continue to build up the wolf's coat with a sharp 2H pencil, noting how the fur length changes from short to long when you move away from the face. Keep your strokes very short and crisp on the muzzle in particular. Darken the fur at the base of the ears and inside, keeping the pressure light on the pencil. After a few layers of pencil, it will gradually begin to darken. Softly add another couple of layers of 2H to the nose. Add a very light layer of 2H to the pupils, iris and inner eye on both eyes. Leave the highlights in the pupils untouched. Ensure the pupils have a rough but not hard edge to them.

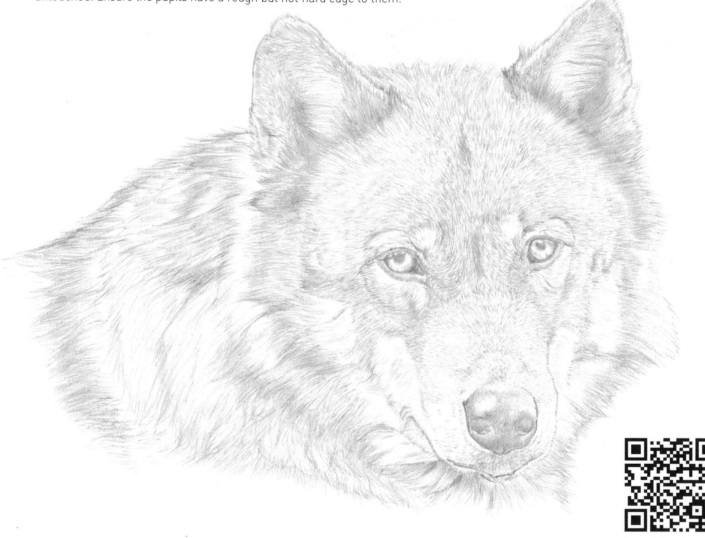

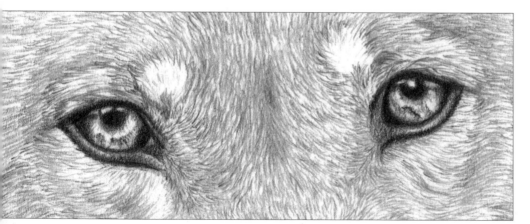

http://cli.gs/b2i1o41

4 Eyes Sharpen a 2B graphite pencil and darken the eyes further, taking care not to press too hard. Light touches can be erased if necessary, but too much pressure makes it almost impossible. Keep the pencil sharp so details stay crisp. Note how the eyes are made up of tiny lines and are not simply solid tones. Gradually build on the depth of the pupils and the eyelids. Sharpen a 3B graphite stick and build on the darks further, finally using a 6B very softly to make the black as dark as possible. These darks will be a guide to how dark the coat will need to be at the end.

5 Nose With the 2B pencil, top up the darks on the nose, again using small circular movements to fill it in. Gently shade over the highlighted areas on the nose to blend them in, as these need to be light grey not white. Next use the 6B pencil to darken the nose further, beginning at the base and working up past the nostrils and towards the top. Make sure the inside of the nostrils are as dark as they can be.

http://cli.gs/b2i1o41

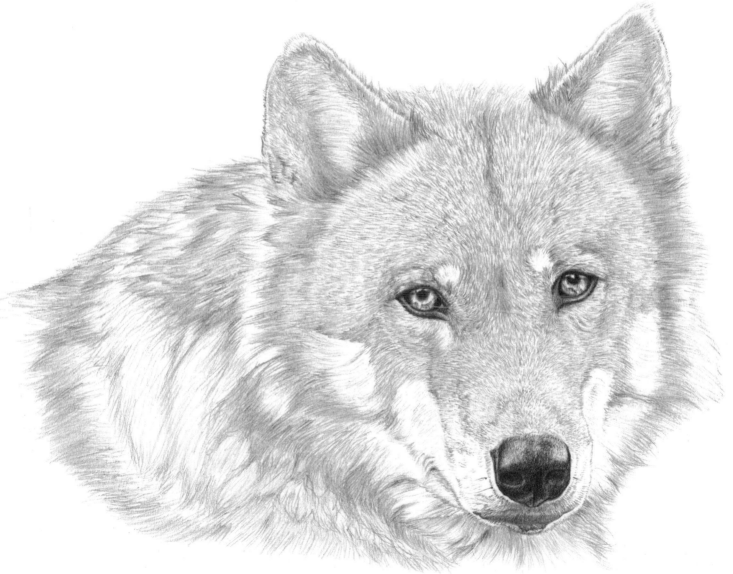

6 Darkening the fur Sharpen an HB pencil and go back over the coat again darkening the fur, in all areas worked on previously. Keep the hairs very short, almost dot-like as you get really close to the nose. As before keep the pencil pressure firm but not hard. As you work continue to monitor how close the tone of the coat is in comparison to the darks of the eyes and nose. It is a long process to build the darks but will be well worth the effort.

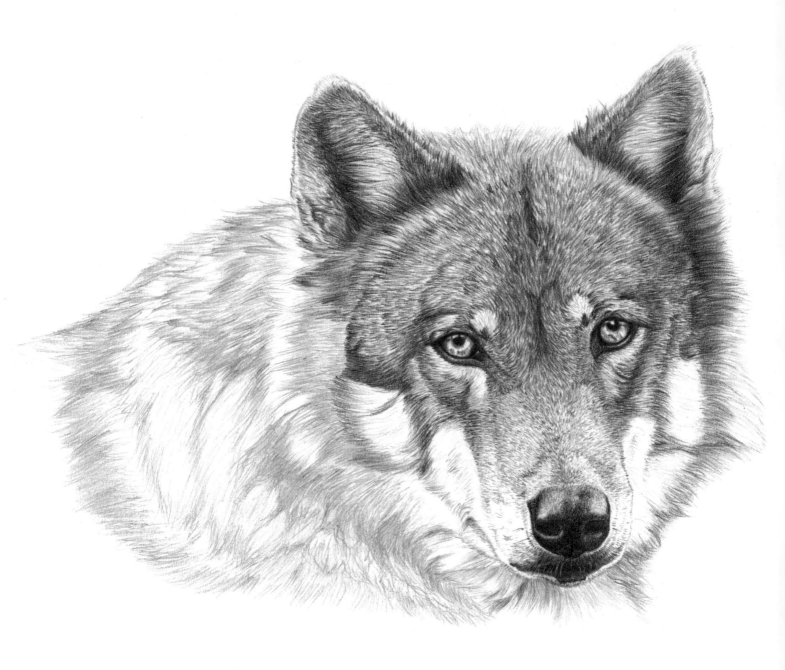

7 **Tone** Now you can sharpen a 6B pencil and use it to really make a difference to the tonal value of the wolf's coat. This pencil will wear down quite quickly and lose its point, so sharpen it regularly to maintain the crisp lines of the hairs and fur. There is no need to use a middle grade pencil as there is a significant amount of pencil already laid down, and a limit to the amount of graphite the smooth card will take. Begin around the eyes and work up towards the ears. The picture above shows what a big difference adding 6B to the head has made – compare it with the unworked neck fur.

http://cli.gs/b2i1o41

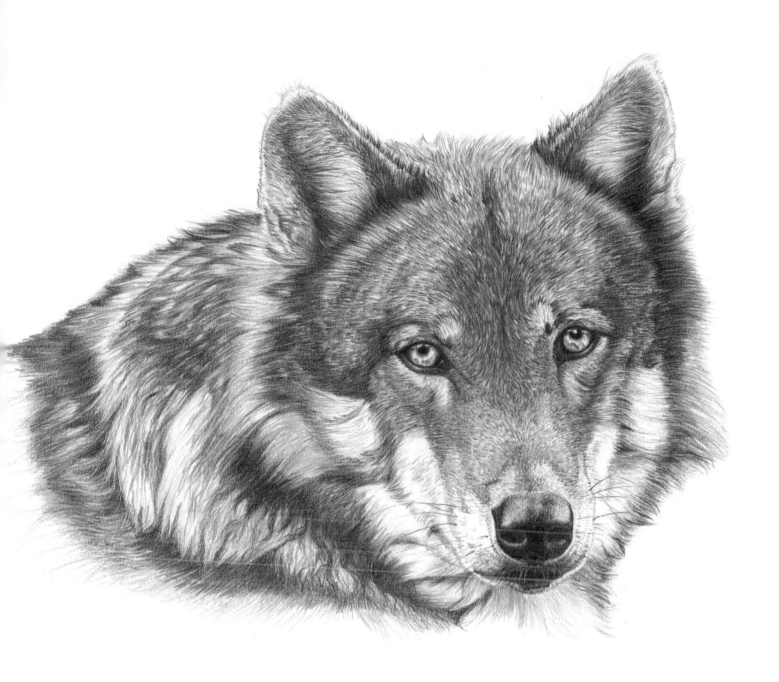

A Portrait of Tatra

42 x 30cm (16½ x 11¾in)

Graphite pencil on smooth white card.

At the final stage, continue to work around the wolf until you have at least one layer of 6B all over. If the darkest area of fur is still not as dark as the nose, add another layer of 6B, keeping the pencil sharp. When this is done, shade over any fur that is not white with the 2H pencil gently, darken the eyes and nose further if required with the 6B pencil and then concentrate on the neck area. Make sure you take time to make the fur on the side of the neck stand out too. Finally, touch up the pupils with 6B, add some whiskers to the muzzle with a sharp 3B, whiten up any highlights with your putty eraser and then sit back and enjoy your artwork!

Meerkat

The meerkat is a very popular little animal. Irresistibly inquisitive and endearing, they have gained in popularity over the last few years. People are drawn to them for obvious reasons and we are comforted by how they care and look out for one another. Although surprisingly small in real life, meerkats are endlessly intriguing. It becomes very apparent when you see their diminutive size that surviving is quite a tall order in their habitat and then the reason for their pack protection behaviour becomes clear.

MATERIALS

Smooth white card, 42 x 30cm (16½ x 11¾in)

2H, B, 3B and 6B graphite pencils

Pencil sharpener

Putty eraser

Embroidery or darning needle

Rough paper

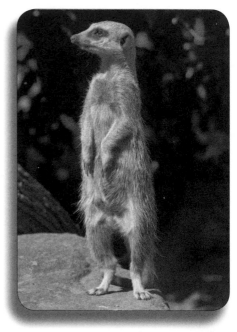

1 Outline Draw the outline using your chosen method of grid, tracing or freehand. This outline is drawn on 30 x 42cm (11¾ x 16½in) smooth white card, with the drawing itself roughly 21 x 30cm (8¼ x 11¾in) in the centre of the paper. The size given is the smallest I recommend you draw, as any smaller will make the meerkat difficult to work on and to showcase the detail.

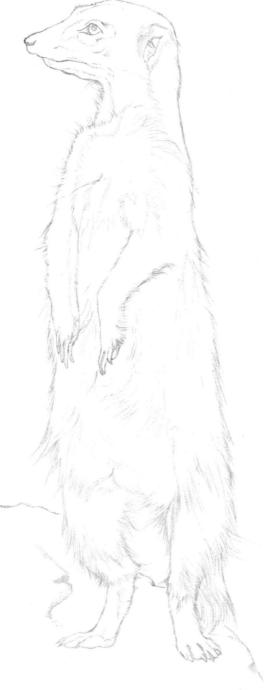

Tip

Do not forget to have a piece of rough paper ready to rest your hand on as you work to prevent smudging.

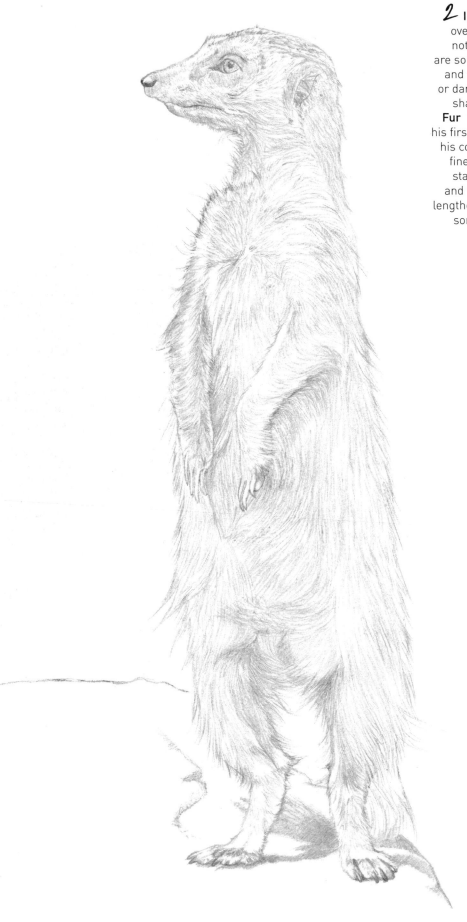

2 Indenting Indent any light hairs that cross over in front of a dark background as you will not be able to add these in afterwards. There are some on his arms, his mouth and chin, neck and the insides of his legs. Use an embroidery or darning needle as these have a thick, not too sharp point to indent these hairs on the card.

Fur Use a sharp 2H pencil to give the meerkat his first layer of fur. Try to leave the highlights on his coat almost untouched by using a very light, fine layer of pencil. Build the fur up gradually, starting with the very short hairs on his head and face. As you move down his body the hairs lengthen gradually. When you get to his feet, add some detail and create the beginnings of the shadow behind him on the rock.

3 Rock texture Sharpen the 2H pencil again and use it to fill in the rock beneath the meerkat. Work from the front of the rock backwards, using a small scribble technique which will give the rock a texture that you can build on. Keep the rear of the rock light, as this section is receding into the distance. Add a couple of layers of 2H pencil to the rock and top up the shadow to make it darker too. Sharpen a B pencil and begin to add the next layer of depth to the meerkat working from the head down.

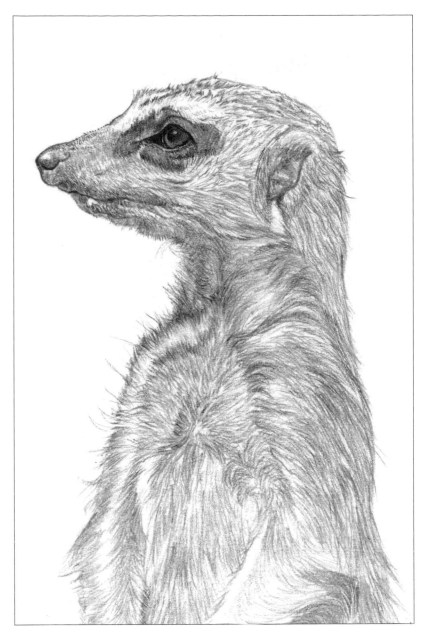

4 Tone Continue to add the B pencil. The marks made by your pencil at this stage have to be very delicate and crisp to create the fur effect. Going too dark too early will not create the texture you are trying to achieve. Work carefully around the highlights so as not to lose them. If you need to make them more apparent, shape your putty eraser and press it on to the area, to lift off some pencil. Work slowly, regularly checking your reference picture and continuing to lean on your rough paper to protect your white background. Keep the pencil tip sharp.

Features Add some more 2H to the iris before darkening further with the B pencil to fill in the pupil softly. Next use the B pencil to create the dark shadow over the top of the iris (cast by the brow) and fill in the inner eye. Darken the nose and mouth line, and the shadow under the chin and on the neck.

http://cli.gs/b2i1o41

5 Adding depth Continue to add more depth over the meerkat's coat using the same B pencil. Darken the rock from the front and begin to fade it out once you go past the middle section towards the back. Darken the shadow by the meerkat's feet. Using the sharp B pencil add another layer on the meerkat. When you can see that the B pencil is no longer darkening and it starts to feel as though it is becoming slightly resistant to the card's surface, sharpen a 3B pencil and go back over the coat again from head to toe. Again, use the putty eraser to extend or replace any lost highlights as you work.

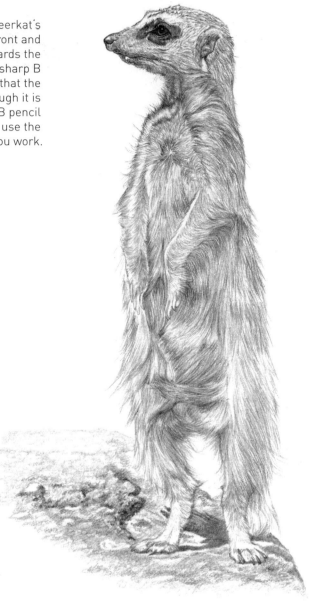

6 Shadows Continue by darkening all the shadows on the coat using the 3B, especially those cast by the backs of his arms on to his body. Add more depth to all the darker fur as this will serve to make the highlights stand out even more.

Details Create further texture on the rock and darken the shadow behind the meerkat. Pick out the detail with the 3B pencil on his fingers, feet and nails and darken where appropriate (see the close-ups below for detail). Your pencil tip must be sharp at all times as you complete these sections.

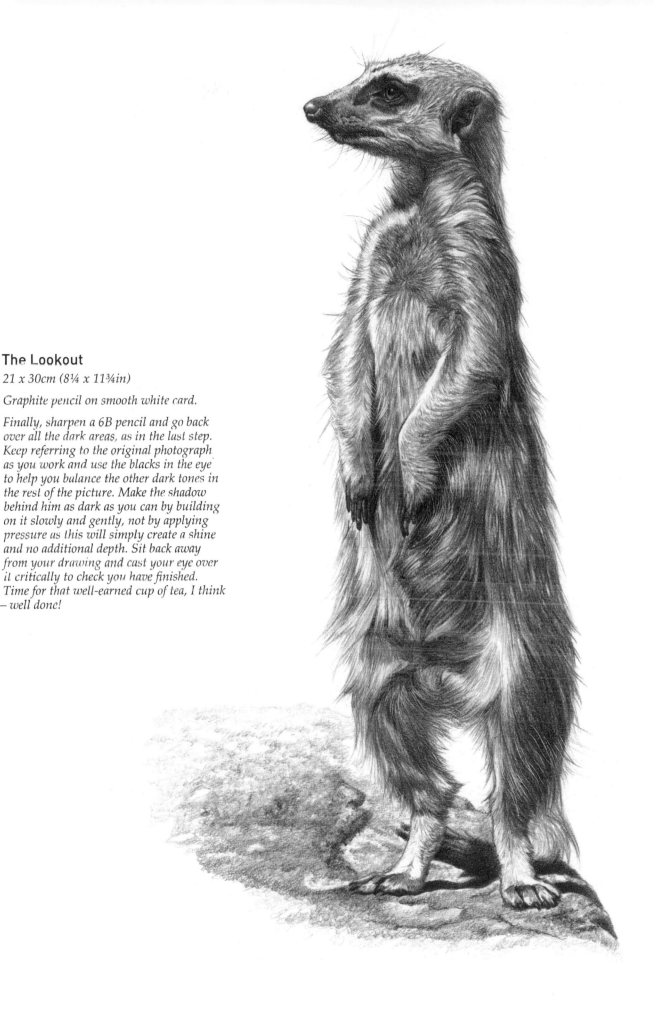

The Lookout

21 x 30cm (8¼ x 11¾in)

Graphite pencil on smooth white card.

*Finally, sharpen a 6B pencil and go back
over all the dark areas, as in the last step.
Keep referring to the original photograph
as you work and use the blacks in the eye
to help you balance the other dark tones in
the rest of the picture. Make the shadow
behind him as dark as you can by building
on it slowly and gently, not by applying
pressure as this will simply create a shine
and no additional depth. Sit back away
from your drawing and cast your eye over
it critically to check you have finished.
Time for that well-earned cup of tea, I think
– well done!*

Elephant

The elephant is an amazing animal, with a brain jam-packed full of ancient maps created from incredible journeys passed down from generation to generation. As adults they are huge but majestic. As calves they are clowns, blundering from one adventure to another. We despair when we see a calf separated from its herd and cheer when it finally rejoins its mother. We mourn with the elephants over the loss of a family member and can relate to their sorrow, humanising their behaviour. They remind us of ourselves – but with better memories!

MATERIALS

Smooth white card, 42 x 30cm (16½ x 11¾in)

2H, B, 3B and 6B graphite pencils

Pencil sharpener

Putty eraser

Rough paper

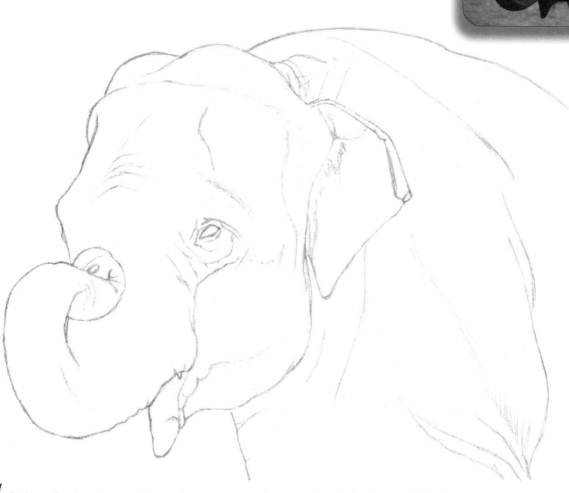

1 **Outline** Start by drawing the outline using your chosen method of using a grid, tracing or freehand. This outline is drawn on 42 x 30cm (16½ x 11¾in) smooth white card, with the drawing itself roughly 30 x 21cm (11¾ x 8½in) in size at the centre. Have a piece of rough paper ready to rest your hand on as you work, to prevent smudging.

40

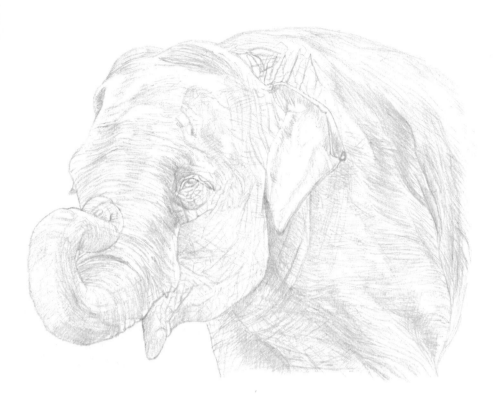

2 Light Before you start creating tone, you need to note that the light is entering the photograph from the elephant's right-hand side. This means that the shadows mainly fall on the left-hand side of the animal, on the tops of the legs and in recessed areas such as under the chin and neck.

Skin Use a fairly sharp 2H pencil to lay down the groundwork of lines, creases and cracks that make up the elephant's skin. Take your time to try to interpret how the muscles and bones under the skin affect the skin above. See how the lines curve over rounded places like the shoulder, chest and trunk. When you have covered the whole area once, go back over with a little more pressure and a sharper pencil point, and add some light shadows to illustrate the curves further. Pay particular attention to her forehead, cheek, ear, shoulder and back.

3 Initial shading Sharpen a B pencil and go back over the elephant, darkening the lines and creases and then begin to deepen the shading over the curves to make them stand out further. Darken the section where the jaw juts out over the neck and chest and where the shoulder meets the tops of the legs. Keep the back lighter and let the furthest part recede into the distance by using a very light touch with the pencil.

http://cli.gs/b2i1o41

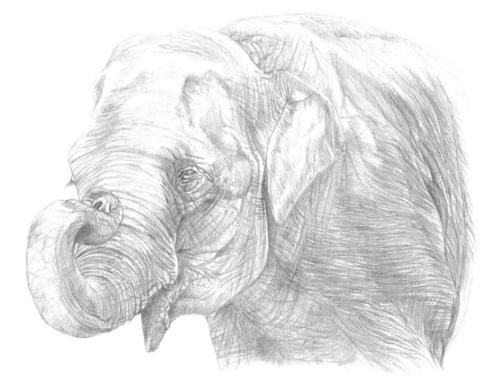

4 Establishing tone Sharpen a 3B pencil and begin by darkening the eye area further. This will help to give you a darkest dark to work from and gauge how much depth to give your shadows. You will need to build on the 3B gradually and keep the pencil fairly sharp as you work. Complete the head first and work towards the back of the elephant, remembering to keep the furthest part of the back the lightest. Keep referring back to the original photograph to ensure your lines and creases bend around any curves on the body. Try to ignore the leaves and dirt on the elephant's back – I think she must have just stood up from a quick dust bath!

http://cli.gs/b2i1o41

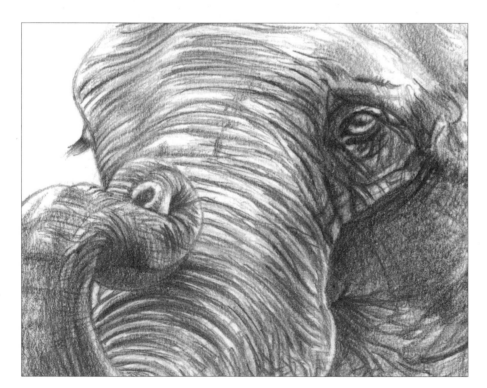

5 Developing the skin Sharpen a 6B pencil and begin to darken the elephant's skin further still. Although this pencil will really benefit the drawing by making your darks strong, do bear in mind that it is a very grainy, soft pencil and you will lose the detail you have previously created if it is overused. The darker you can make the front of the elephant however under the chin, the more the head will stand out. Use the pencil without pressing too hard or a shine will be created on the card and you will be unable to add any more pencil to this area.

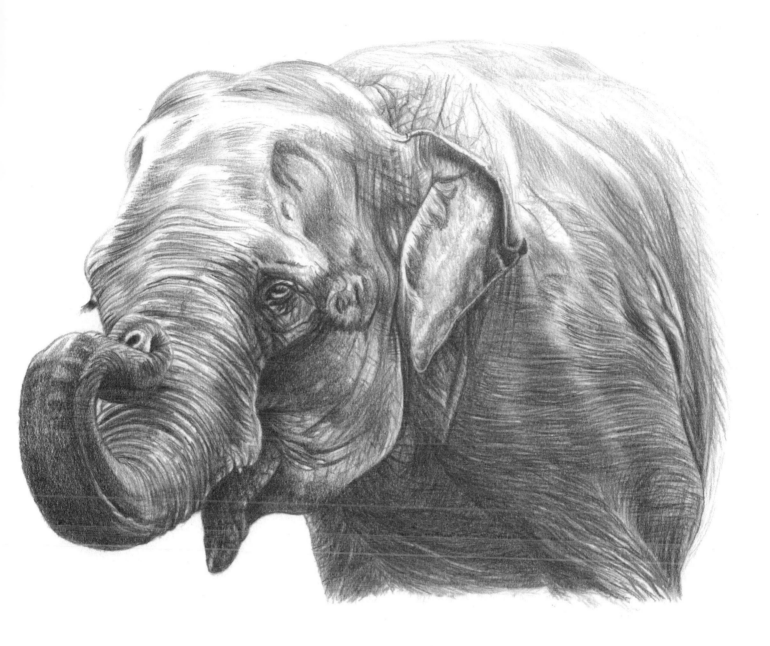

The Greeting

30 x 21cm (11¾ x 8¼in)

Graphite pencil on smooth white card.

At the final stage, continue over the body of the elephant, darkening the lines and creases as well as deepening the shaded parts further. If you lose too much detail, use your putty eraser to lift off unwanted pencil. You can also use the putty eraser to lift out highlights too if they have disappeared. Your final drawing should resemble the picture above, where the 6B has been added in two or three layers all over.

Tiger

The tiger is one of the most popular big cats but they are also one of the most challenging to draw or paint. It is very easy to get lost when reproducing the stripes, and getting these correct while maintaining the shape and structure of the head can be a bit tricky!

A lot of planning is required for this subject. The more time spent observing and studying the reference photograph before you begin, the easier it will be to complete. I have used the grid to enlarge my reference photograph, in order to make my outline close to 30 x 42cm (11¾ x 16½in) in size, rather than 21 x 30cm (8¼ x 11¾in), which is quite small and would be fiddly to work on.

MATERIALS

Smooth white card, 30 x 42cm (11¾ x 16½in)

2H, 2B, 3B, 6B and 9B graphite pencils

Pencil sharpener

Putty eraser

Knitting needle

Rough paper

Tip

Rest your hand throughout on a piece of scrap paper to prevent smudging and to keep your whites as white as possible.

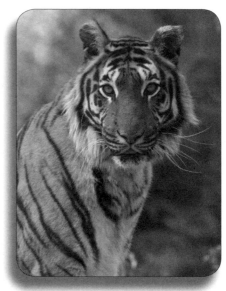

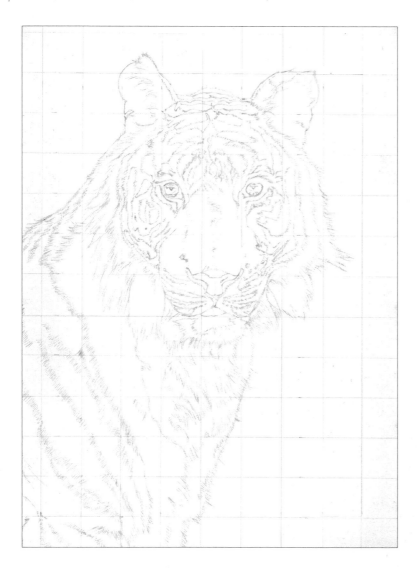

/ Outline Go through the steps on pages 23–24 to complete your grid on your card, using a 2H pencil very softly so you can erase the gridlines easily when you no longer need them. Beginning with the ear on the left-hand side of the drawing (the highest point of the image), plot where to begin on your card and work down copying all the details you see within each square. Stop to check now and again that there are the same number of squares between certain points, for instance beween the eyes and the jaw. Compare the number of squares on your paper with the number on the grid. This will ensure you have copied over the outline correctly before adding detail. Use an eraser to remove the grid lines before continuing.

Indenting hairs Use a knitting needle to score the whiskers on to your outline, starting from the root and working out to the tip. This needs to be a very confident sweep of the indenting tool as you can not correct this indentation, so practise on some spare card before you start. When you first shade over this area, use a soft 2B pencil to shade across the indented area, being careful not to let the pencil point fall into the scored lines as removing this will be hard. Your indented whiskers will begin to stand out from your background as you work.

2 Create a 'soft focus' background behind the tiger, using your 2H pencil slightly on its side (not directly on the point as this creates too much pressure). Work gently and diagonally across the card from the top left-hand corner of your card down to the bottom right-hand corner. (If you are left-handed begin at the top right-hand corner and work down to the bottom left, as this will feel more natural.) Next, use a blunt-tipped 3B pencil to go over the same area with a circular motion, keeping your strokes soft and gentle with very little pressure. The further the tip wears down on the pencil the easier it becomes.

Blending Use a clean dry finger to blend the background in small circular movements, then use a 6B pencil to darken the background further but begin to create some depth by being selective in the areas you use it. Remember that that the light is entering the picture from the top left (see reference picture).

Darkening Use a 9B graphite stick to darken the background further, mainly at the bottom. Press a putty eraser on to the background gently and lift off areas to lighten and add more interest.

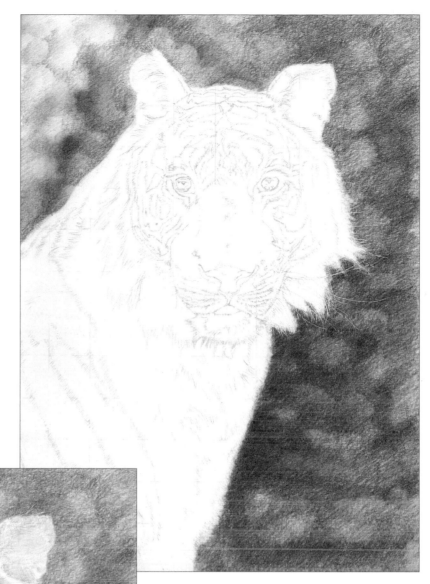

3 **Stripes** Using a sharp 2H pencil, start to fill in the stripes, beginning at the top of the tiger's head. This makes it easier to map where you are as you work. Work from root to tip, stroking in the hairs while keeping a close eye on the hair direction and shape of each stripe. Make sure you leave the white areas as untouched as possible, and do not forget to fill in the inside of the ears.

Fur When the stripes are complete, begin to add the darker fur between the stripes, again noting first where it changes from dark to white and copying the fur direction.

Tip

It is very easy to go wrong at this stage, so take your time and have regular breaks. If you step away for a while, you can quite often pick up a mistake and fix it before you compound it further.

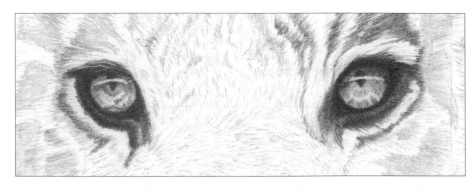

4 Eyes Begin with a sharp 2H pencil and start to shade in the iris, taking into account all the markings in both eyes and noting that they are made up of small lines. Alternate between the eyes as you work to keep a balance.

Shadows There is always a shadow cast by the eyebrows at the top of the eyes, as the eye itself is set back in the socket. This shadow is very important and adds a lifelike quality. Begin with this darker section at the top of the eye, and shade from the top of the iris down towards the centre. Leave the highlight that sweeps across the pupil white and continue down, gently shading what you see. Next, use a sharp 2B pencil to darken the shadow at the top of the eye further. Do not be tempted to draw a line around the highlight, just shade around it and give it a fuzzy edge to blend softly into the eye.

Iris Shade the irises of both eyes, working in towards the centres from the outside edges. Next, use a sharp 6B to begin to darken the eyelid and the area of the eye around the outside of the iris. Fill in the pupil, leaving a rough edge to it and darken the brow shadow further at the top. Darken the markings in the eyes where necessary. Be careful not to apply too much pressure with the 6B or a shine will begin to form and this is not reversible. Finally, use a sharpened 9B graphite pencil to darken the pupil and around the eye socket further. Again use this softly, as it produces a grainy effect and you can lose detail previously created.

http://cli.gs/b2i1o41

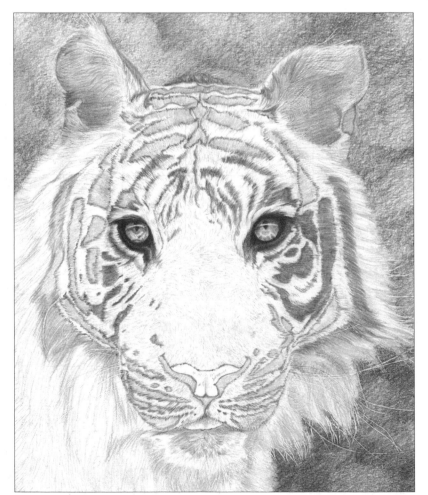

5 Darkening the stripes Now that the eyes are complete you have a guide to how dark your stripes need to be. This is best done gradually with several soft layers of pencil. Pressing hard with a high grade pencil will only produce a shine and no depth. Use the 2B to create ragged shapes representing the stripes before filling them in. This prevents you extending the stripes while shading and prevents your tiger ending up with a wonky face! It is very easy to get carried away and lose the shape of the stripes. These are important and follow the bone structure and muscles that give the tiger its striking face shape. Continue around her face being careful to fill in the correct areas. Note that the length of the hair changes when you complete the fur around the sides of her head. Darken the insides of the ears.

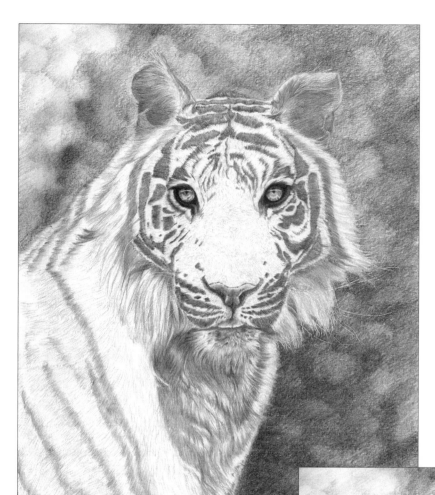

6 Adding depth Continue to work down the tiger with the 2B pencil, keeping it sharp. Add some depth to her nose and begin to build on the 2H layer of pencil already on her chin and neck/chest fur. Keep referring to the original photograph for the hair direction. Darken the stripes across the back of her neck and begin to work down towards her shoulder and chest.

http://cli.gs/b2i1o41

7 Features Now use a sharpened 2H pencil to begin creating the hairs on her nose. This is a complicated section that requires patience, so do take regular breaks! Once the 2H is added all over the nose, begin to darken further with a sharp 2B pencil. Notice how the hairs where they meet the forehead double in length, especially on the bridge of the nose. There is also some scarring on the nose which is part of her personality and makes her unique. Use the 2B to darken the fur between the white areas around the eyes, forehead and muzzle.

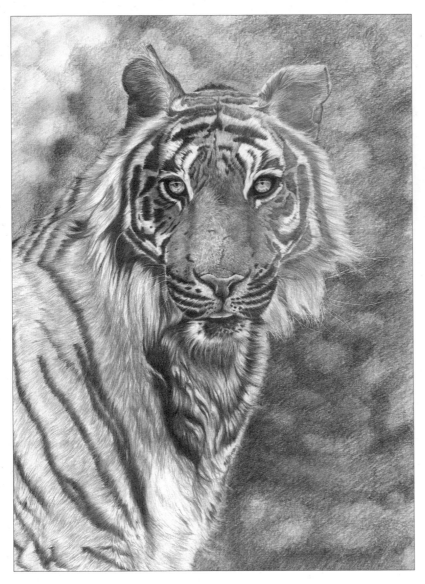

8 Creating impact Now you need to add the 'wow factor' to your tiger. Sharpen a 6B pencil and begin to darken the stripes on the head to match the depth of the eyes. Take your time and do not forget to darken the mouth, body stripes and chest fur too. The main picture (left) shows the left side of the tiger's face (right of the picture) still to be darkened further with the 6B pencil, which illustrates how much impact using the 6B pencil has had on the drawing already.

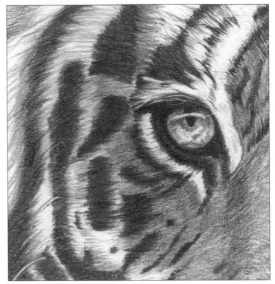

This close-up detail of the tiger's right eye shows how important the direction of the fur is: your eye follows the contours of the face created by the flow of the hairs. The depth of shading of the mid-tone fur between the white sections of hair must be dark enough to make the white stand out but not so dark that it matches the depth of the black stripes.

http://cli.gs/b2i1o41

Opposite
Indie

30 x 42cm (11¾ x 16½in)

Graphite pencil on smooth white card.

As you reach the end, continue to work around the tiger using the 6B pencil to darken the fur between the black stripes on the back and shoulder areas. You can also use a 9B graphite stick to darken some key areas if needed. Remember not to press too hard or your darks will become shiny and hard to see. Keep the 6B pencil sharp and work between the white whiskers on her cheeks to darken the fur to help them stand out. If the whiskers are not wide enough or do not stand out quite the way you would like, use an electric eraser tip (not turned on) to gently work along the whisker root and erase selectively to widen them. Lighten the background by rolling the putty eraser into a ball and use it to remove some pencil if it is too dark in places. Darken the left-hand side of the tiger's nose (right of the picture) and face where a shadow has formed. Top up the depth of the pupils and use a putty eraser shaped into a small tip to whiten up the highlights in the eyes. You can also the use the putty eraser to whiten any other areas that need to stand out more. Finally, sign your masterpiece!

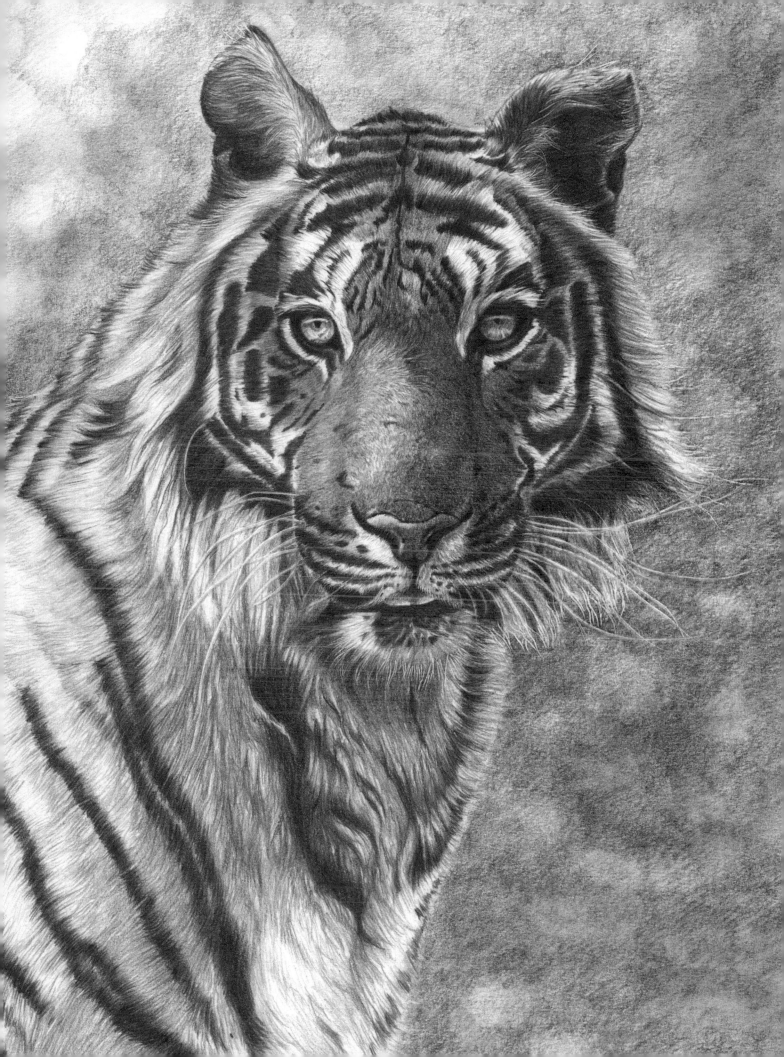

Cheetah

The cheetah is easily the most elegant of the big cats. Always aloof, they are slender and graceful but possess the stamina to produce speeds of up to 60mph (97 kph) from almost a standing start. Unlike lions, they prefer to hunt in the daylight hours, using their speed to take their prey by complete surprise.

As a parent the cheetah is as dedicated as all the other cats, with her litter of up to three cubs staying with her up until they reach two years of age. However, she will bring them up on her own without a support network of other cheetahs, unlike lions who use the lionesses in the pride as adopted aunts. The cheetah has a grace and poise which make her stand out from the crowd.

MATERIALS

Smooth white card, 30 x 42cm (11¾ x 16½in)
2H, B, 3B and 4B graphite pencils
Pencil sharpener
Embroidery needle
Rough paper

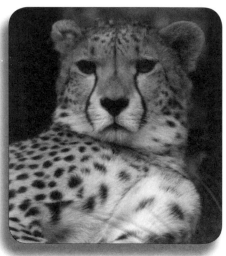

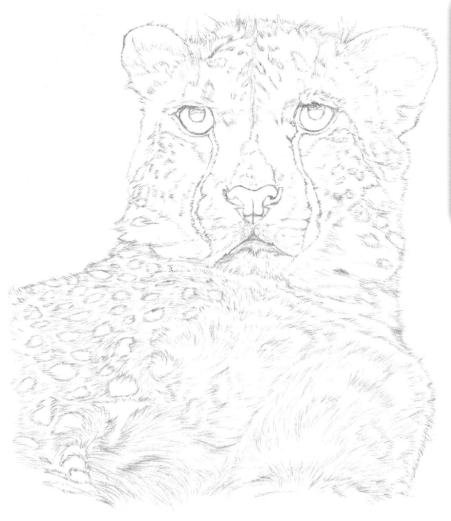

Outline First, draw the outline using your chosen method of grid, tracing or freehand. This outline is roughly 21 x 30cm (8¼ x 11¾in) in size and drawn in the centre of a 30 x 42cm (11¾ x 16½in) piece of smooth white card with a 2H pencil. Keep your pressure light when drawing this outline so that mistakes are easily erased and rectified. Have a piece of rough paper nearby to rest your hand on as you work, in order to prevent smudging.

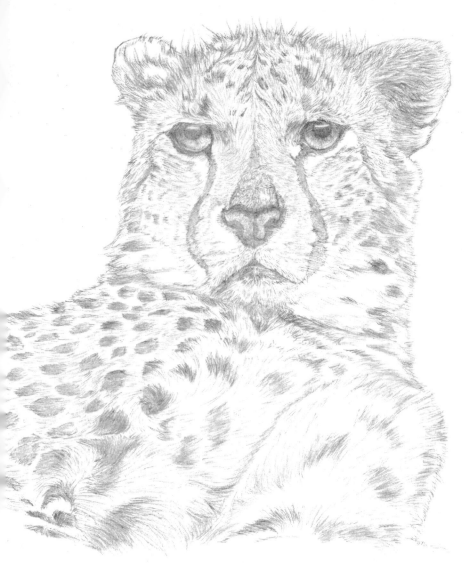

2 **Shading** Before you start shading, decide where you want to indent any hairs or whiskers. The key places are the white whiskers on the cat's cheeks, chin, mouth and the short hairs on the top eyebrow overhanging the eyes. Use an embroidery needle to make the indentations, but be sure to work slowly and with precision as you can not undo these marks.

Markings Continuing with the 2H pencil and keeping it sharp begin to work down from the top of the cheetah's head and fill in the spots gently, copying the fur direction from the reference photograph. As you move down the face and body, look back at the reference for changes in fur direction and length. The fur must go in the correct direction to show the position the cat is lying in and the bone structure underneath. Add the light hair to the inner ears and begin to put in a light layer of fur between the spots too. Leave the very white sections of fur untouched so they stand out later. Outline the eyes and fill in the tear track markings on the cheetah's face. Shade in the pupils keeping the edges rough and add some 2H to the iris in both eyes also. Observe carefully where the light sections are in the iris and shade accordingly. Do not forget to add the shadow cast by the brow over the top of the iris and leave the highlights in the pupils untouched.

3 **Establishing tone** Sharpen a B pencil and begin to darken the eyes. Use gentle curved strokes to add a darker shadow to the top of the iris in both eyes and add more depth to the pupils too. Strengthen the lines around the outer edge of the eyes and accentuate the hairs sticking out over the top of the eyes from the eyebrows. When you feel that you can darken no further with the B pencil and that the pencil is skating slightly, sharpen a 3B pencil and repeat the process from scratch again to darken the eyes even more. Take time and care to create the eyebrow hairs, keeping them crisp and light and the area underneath dark so they stand out. If done well it can look very effective!

http://cli.gs/b2i1o41

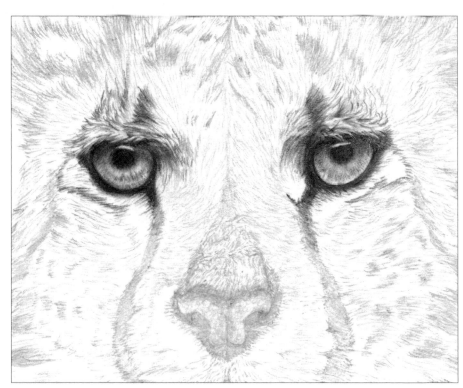

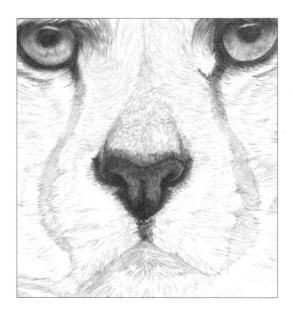

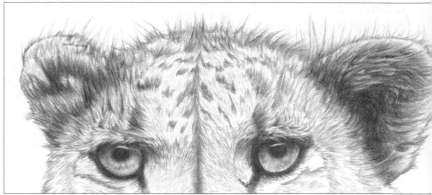

5 **Ears** Move back to the head again and begin to put in the darker hairs on the top, with a sharp B pencil. Work down the face until you meet the brows again. Keep the pencil tip sharp. Now start to add the darker hairs at the base of the cat's left ear first and outline the whole outer edge of the ear with tiny little hairs, interspersed by slightly longer wispy ones. Next, build up the hairs within the ear itself, studying the reference first for hair direction. Add some B to the inner ear, making the centre as dark as possible. Now use a sharp 3B to darken the ear further in the centre to match the depth of the pupils. Add longer dark hairs at the base of the ear, close to the top of the head and flick them upwards in one fluid motion. The cat's right ear is actually facing backwards, so what you are seeing is the ear almost back to front! This ear is in listening mode... Complete this ear using the B and then 3B as before.

4 **Nose** Now use a B pencil (with a sharp point) to add some darks to the nose. Begin by checking your outline is correct and then fill in the nostrils gradually making them darker and darker. Next deepen the darks on the nose itself by using the pencil (which is now less sharp) in small circular movements, to add texture all over. Keep looking at your reference for detail. When you feel the need to apply more pressure to the B pencil to darken your shading further, this is the time to change pencils to a sharp 3B as before. Continuing with the B will only increase the shine and add no more depth. Repeat the process of darkening as you did before with the B pencil.

http://cli.gs/b2i1o41

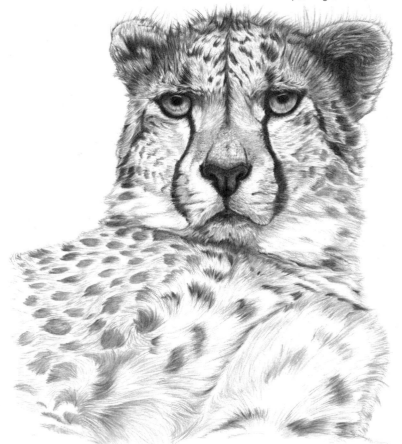

6 **Fur** Continue back down the face using a sharp B pencil, darkening the tear lines, mouth, chin, right down to the neck, filling in the spots as you go. Shade the spots carefully with the pencil, checking your reference regularly to ensure you keep to the shape of the face in particular. When you get down to the chest fur, keep the pencil movements long and flowing to create the longer hairs. The picture with this step shows the head only with B added, showing the difference this grade of pencil makes. When you have gone as dark as you can with the B pencil, sharpen the 3B again and go back over the head and all details as you did with the B.

A Class Act

21 x 30cm (8¼ x 11¾in)

Graphite pencil on smooth white card.

At the final stage, use the B and 3B to add some shading to shape the head and body and make them appear three-dimensional. Add 4B to darken all of the spots and other key areas just a little more. Finally, add your black whiskers to the cheeks with a sharp 3B pencil and you can relax as your cheetah is complete!

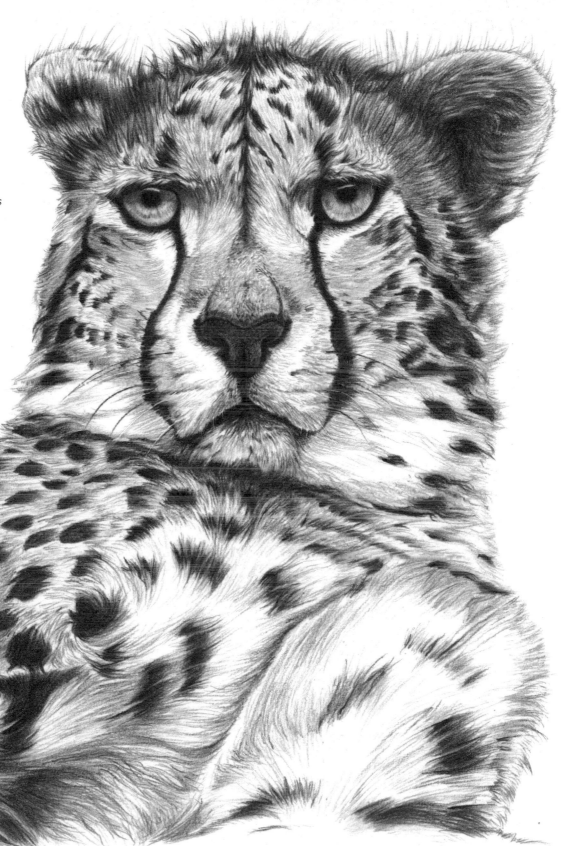

53

Dogs

There are many different shapes and sizes of dog, too many to make reference to in this book individually. However, there are a few common shapes that we would all recognize instantly.

Face shapes

Barring variations in size and some particularly unusual breeds, dogs' heads fit into a few broad shapes. These are round head (Pug, Staffordshire, and similar), narrower face with long muzzle (Border Collie, German Shepherd), square head (Bull Mastiff, Labrador type) and finally small and fine-boned pointed face (Papillon, Chihuahua). These pages illustrate two of the more common and distinctive head shapes.

Round head

One of the most common breeds is the Staffordshire Bull Terrier. When drawing this breed, ensure that the ears are almost on top of the head. The eyes are small and set quite far apart, the jaw is square with a wide mouth, compact nose and short muzzle. The main distinguishing feature of this breed is their neck, which is almost as wide as their waist! Staffordshire Bull Terriers are known for their stamina, and their robust build reflects this well.

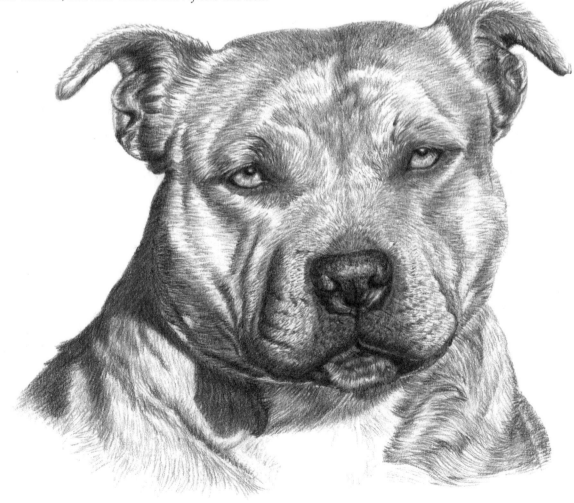

Long muzzle

The Border Collie, another well-known breed, has a narrower face with a long muzzle. The ears are positioned high on the skull at the top and can be pricked (upright) or tipped (folded over).

The coat is not always long; some Collies are short-haired but the traditional appearance is black and white with medium length fur. The facial colouring of a typical Collie will include a white muzzle and a streak of white hair in the centre of the forehead. This streak can be wide or narrow depending on the dog.

Many Collies are not of pure pedigree and so come in all shapes and sizes, but in general they are light in frame, highly energetic and have an inquisitive expression in the eyes, especially if you are holding a bull!

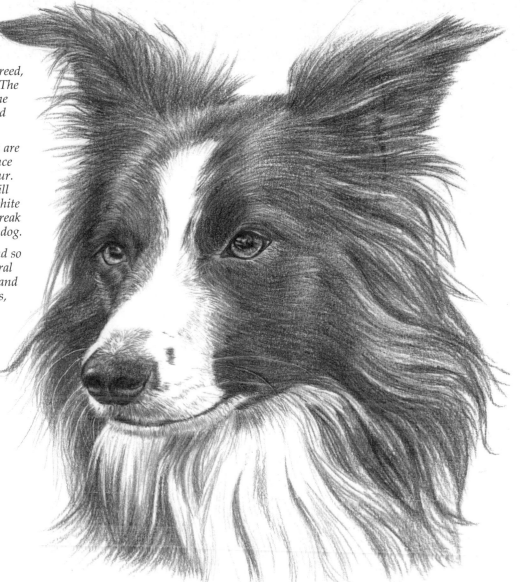

Eyes

Dogs exhibit numerous different eye shapes, but one of the most unusual is the bulbous, deep-set eyes found in breeds of dog like the Pug, Chihuahua and the Bulldog. Bulldogs' eyes (see upper left for an example) are heavy-set, matching their solid and compact body shape. The eye itself is round in shape, with a large brow above. The eyes are set quite wide apart and a lot of the bottom inner eyelid is on show, which is a big characteristic of this breed.

The example eye on the lower left is that of a Rhodesian Ridgeback, but the overall shape is very similar in lots of medium-sized breeds, including Retrievers, Labradors and Hungarian Vizslas. If you drew a diamond to start with, you would not be far wrong. There is a defined brow but it is more refined. There is almost no sign of the inner eyelid and the overall look is clean, crisp and very direct!

Ears

Ears can be amongst the most distinctive features of a dog breed. Easily recognisable are the ears of the German Shepherd (see upper right). Their most common coat length is medium to long and this includes long hairs within the ears themselves. The ears are usually upright rather than tipped but sometimes a dog will have one ear at least that fails to spring upright and match the other in adulthood. This can be quite appealing!

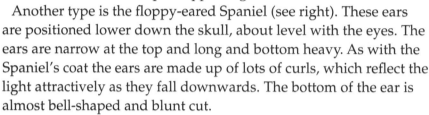

Another type is the floppy-eared Spaniel (see right). These ears are positioned lower down the skull, about level with the eyes. The ears are narrow at the top and long and bottom heavy. As with the Spaniel's coat the ears are made up of lots of curls, which reflect the light attractively as they fall downwards. The bottom of the ear is almost bell-shaped and blunt cut.

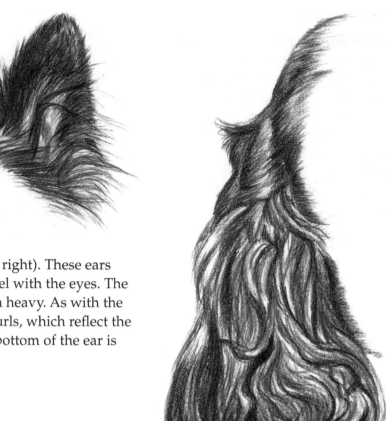

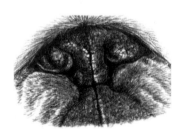

Noses

As with eyes and ears, dog breeds have a few basic shapes of nose. Few are as distinctive as those of the Pug or Bulldog, which are tucked away within the face rather than standing proud of the muzzle like the Border Collie on page 55. The example on the upper left is of a Bulldog's nose. Note how the hair above the nose almost rolls over the top like a protective carpet and the overall texture of the nose itself is quite raised.

In contrast the nose of the Labrador (see the example on the lower left) is very obviously on the end of the face and is the first feature to meet you in a greeting! The nose can be quite large and in different breeds of Labrador or Rhodesian Ridgeback it can be liver-coloured or black. It is smoother in finish and much rounder than the Bulldog's and the fact that it is proud of the face also aids breathing.

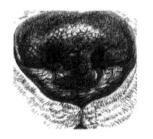

Body shapes

Dogs' body shapes vary so much from one breed to another that it is hard to make any but the broadest statements about them in general. However, when it comes to recognisable body shapes I think you will agree that the popular breeds shown here are rewarding to draw. With variation in the proportions, the principles apply to dogs in general.

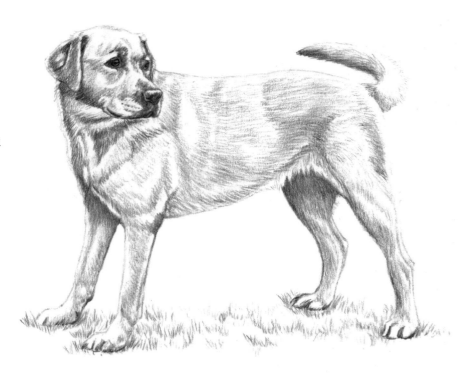

Labrador Retriever

One of the most popular breeds has to be the Labrador. They are of medium build, stand a lot taller than the Staffordshire Bull Terrier and are thicker set than the Border Collie. The Labrador has a square head shape, wide shoulders and a solid, strong body shape. The coat is thick and soft – almost luxurious – and the hair length is generally about 5cm (2in) long.

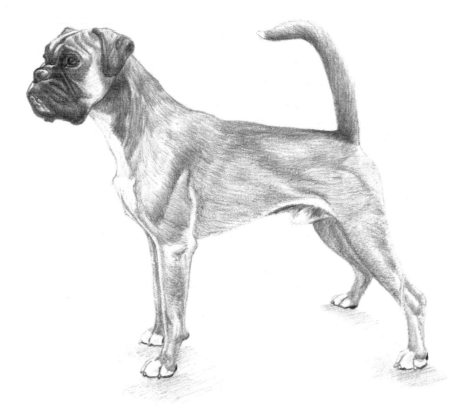

Boxer

Another easily recognisable breed is the Boxer. Their face, with its characteristic lack of profile, is very distinctive! The eyes are set wide apart and are quite round in shape, while the nose is small compared with the size of the head. They have a large jowl and a wide, almost rectangular, head shape. Their expression could be described as 'dopey' but this belies their true intelligence. The ears again are set quite high on the head and are mainly folded over rather than pricked. Their body shape is very front-heavy, with a deep barrelled chest, a strong back with a high waist leading to strong, muscular legs. The Boxer's coat is very short and lies close to the skin, giving it a buffed and shiny appearance when in good health.

Poppy

As we know, dogs come in all sizes, shapes and colours. The subject I am using for this project is a rescue crossbreed called Poppy. Poppy is one of the lucky ones, having found a loving home with the lady who rescued her. I decided to use Poppy in particular as her black and white colouring is an enjoyable challenge to emulate with graphite pencil. The dark effect is created slowly and methodically, with firm – but not heavy – pressure, and building up gradually using several layers.

In this lesson you are going to see how to create this dog using a different method from that used so far. Instead of building the depth gradually, the highlights are created using a 4H pencil to help resist the high grade of soft pencil to come and the darks are created immediately using a 6B pencil. Using the method previously taught in the book would use up too much tooth on the card as it is almost non-existent. The method involves going straight in with the dark after highlighting the light areas with a hard pencil, to repel the dark pencil as you shade into and over it in places.

MATERIALS

Smooth white card, 30 x 42cm (11¾ x 16½in)
4H, 2H, 3B and 6B graphite pencils
Pencil sharpener
Putty eraser
Rough paper
Embroidery needle

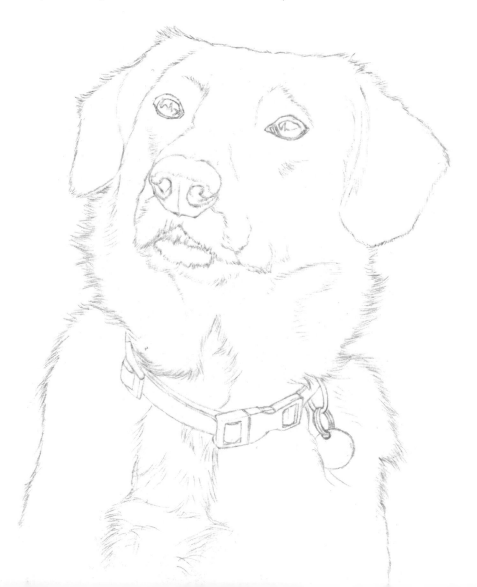

Outline Draw the outline using your chosen method of grid, tracing or freehand. This outline is drawn in the centre of a 30 x 42cm (11¾ x 16½in) piece of smooth white card with a 2H pencil and the drawing is around 21 x 30cm (8¼ x 11¾in) in size. Keep your pressure light when drawing this outline so that mistakes are easily erased and rectified. Do not forget to have a piece of rough paper ready to rest your hand on as you work to prevent smudging.
Indenting whiskers Before beginning to shade, use an embroidery needle to indent the dog's whiskers on her muzzle, starting from the root and working out to the tip. This stage is irreversible so make sure you know where your whisker is heading before you start at the root.

2 Face Start to add highlights on the right-hand side of her head using a sharp 4H pencil. Begin with the top of the ear and add all the light areas with gentle strokes on the surface of the ear. Now add the 4H to the shiny areas on the top of her head with shorter strokes, following the hair direction from your reference picture. Reaching the eye, add the lines which curve over the eye brow bone, underneath the eye and then leave a gap for the dark 6B area to come. Continue again with the 4H, referring to the photograph to get the areas of shine on her face correct. Add some 4H in the curve where the hairs flick out on the right side of the face adjacent to the muzzle. Begin to mark out the white hairs above the mouth on the front of the muzzle using the 4H.

Strengthening Sharpen a 6B and go back up to the top of the head. Begin to fill in all the dark sections starting directly above the eye, gently running the 6B into and through the 4H lines already laid previously. You can use the 6B to fill in the corner of the eye working upwards towards the brow and then move to the top of the brow bone and shade from left to right into the 4H lines. This filling in from both directions means you properly integrate the highlight by shading from both ends so it becomes part of the dark area. Continue to work around the eye with the 6B and then work down to the area under the eye and beyond. Your previously marked areas in 4H should now be showing as lighter highlights within the 6B shaded sections. When you reach the indented whiskers ensure that you shade across them not horizontally along the length of them as you could inadvertently fill them in. As you cross them with the 6B and build up with a couple of layers, they will begin to show up more. Go back to the eye and use a 2H to add a soft layer to the iris and pupil, leaving the highlights in the pupil untouched. Use a sharp 3B to darken the pupil and iris further. Outline the eye with this pencil and then sharpen your 6B to darken the eye overall.

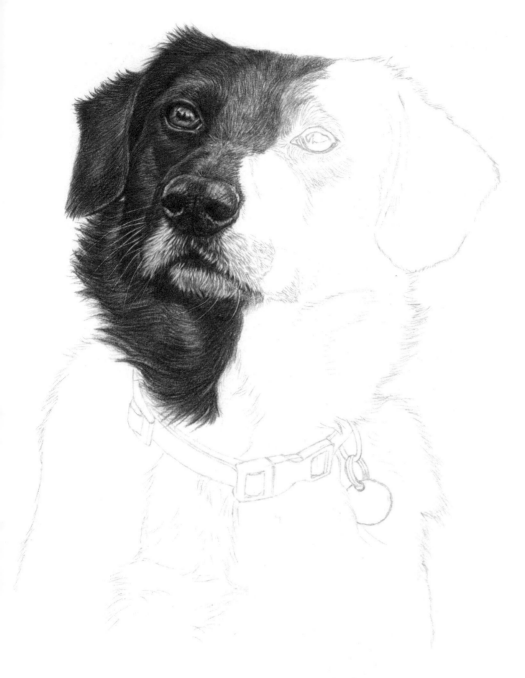

3 Features Go back to the top of the head and sharpen the 6B before adding the darks to the already prepared ear. Make sure you have added enough 4H to keep the highlights before you fill it in completely. If there are insufficient highlights left on the ear, use the putty eraser to lift some pencil off. Move down to the muzzle again and use the 4H on the chin hairs as you did before to create the white hairs above the lips. Now use a sharp 2H to add more detail to these hairs, taking care to keep them as white as possible. Next use a sharp 6B to shade in the dark area between the lips and take some 6B into the hairs overlapping the mouth. Fill in the area under the chin using the 4H again first for any highlights and then shade the darkest areas with a 6B pencil and then a 3B pencil.

Tip

Building up in layers from light to dark ensures a sharper finish to the nose than if you go straight in with the 6B.

4 Nose To complete the nose, sharpen a 2H pencil and use this to add the first layer of texture to the nose. Study the reference. Use a combination of a scribble technique plus small, crisp lines to create this texture. Fill in the nostrils. Next, use a sharp 3B pencil to darken the nose further, building on the texture you have created. Darken the nose where required and add more depth to the nostrils. Finally, sharpen a 6B and darken the nose using two or three layers of pencil. Again, use the putty to help lift off the highlights if they are not obvious enough.

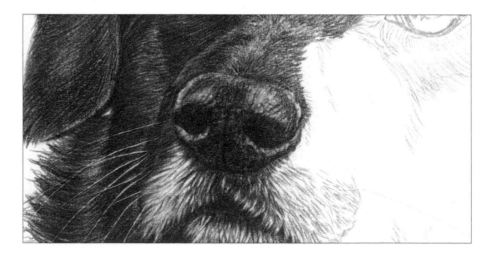

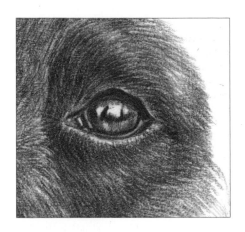

http://cli.gs/b2i1o41

5 Features Use the 4H to create the short highlighted hairs on the section above the nose, making sure that the hair direction is correct as you work towards the area between the dog's eyes. Use the 4H right up from between her eyes to the top of her head. Next use a sharp 6B to shade in from the top of the nose towards her eyes again. Fill in right up to her forehead and on to the top of her head. To complete her left eye use the 4H again to add all the highlights as you have done before previously. Use the 4H in all the light areas on the brow bone above the eyelid and below the bottom eyelid, completing those in the cheekbone too. Sharpen the 6B and begin by outlining the dark line beneath the iris and filling in the corner of the eye. Next, darken the area inside the eyelid and above the iris, then fill in the pupil using the 2H and 3B first, leaving the highlights untouched, as on the other eye. Darken the eye further using a sharp 6B. Now use the 6B to complete the darks above and below the eye and then work the 6B into and over the 4H already applied on the cheekbone.

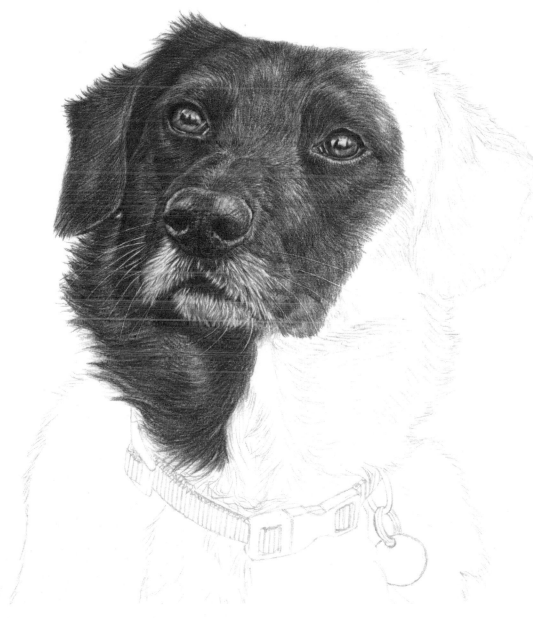

6 Fur Continue to work down the left-hand side of the dog's face by first adding 4H to the light areas and then 6B to fill in the darker sections. Work down towards the collar, slowly and methodically. When you reach the white section of fur in the middle of her neck, use a sharp 2H to draw in the segments of white hair and use a sharp 3B to add a little shadow within the white to break it up and separate the hairs. Darken the shadow under the chin, so that her muzzle comes forward out of the card.

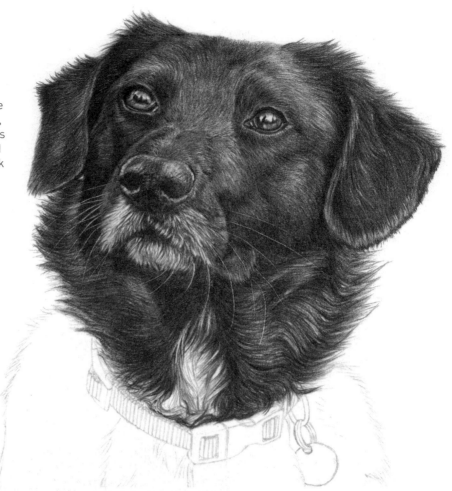

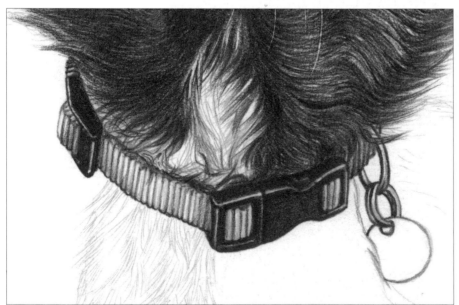

http://cli.gs/b2i1o41

Opposite
Poppy
21 x 30cm (8½½¼ x 11¾in)

Graphite pencil on smooth white card.

At the final stage, build up the white fur centre section below the collar as you did before on the white fur above, using the 2H and 3B pencils. Sharpen the 6B and add a little shadow and a few black hairs within the white fur. Build up Poppy's neck and the top of her shoulders using the method of 4H to add the highlights and a sharp 6B to create the darks. Clean up the background with a putty eraser and use the same eraser to lift off and bring out any highlights that require polishing up.

7 Details To complete the collar, shade in the material part with a sharp 2H pencil first. Outline the buckles and metal rings with this pencil once the material is established. Next, shade in the material again and add some texture still using the 2H and use the same pencil to shade the buckles and rings, leaving the highlights untouched. Now sharpen a 3B pencil and darken the black plastic buckles and material section further. Continue to add more layers to darken the collar overall.

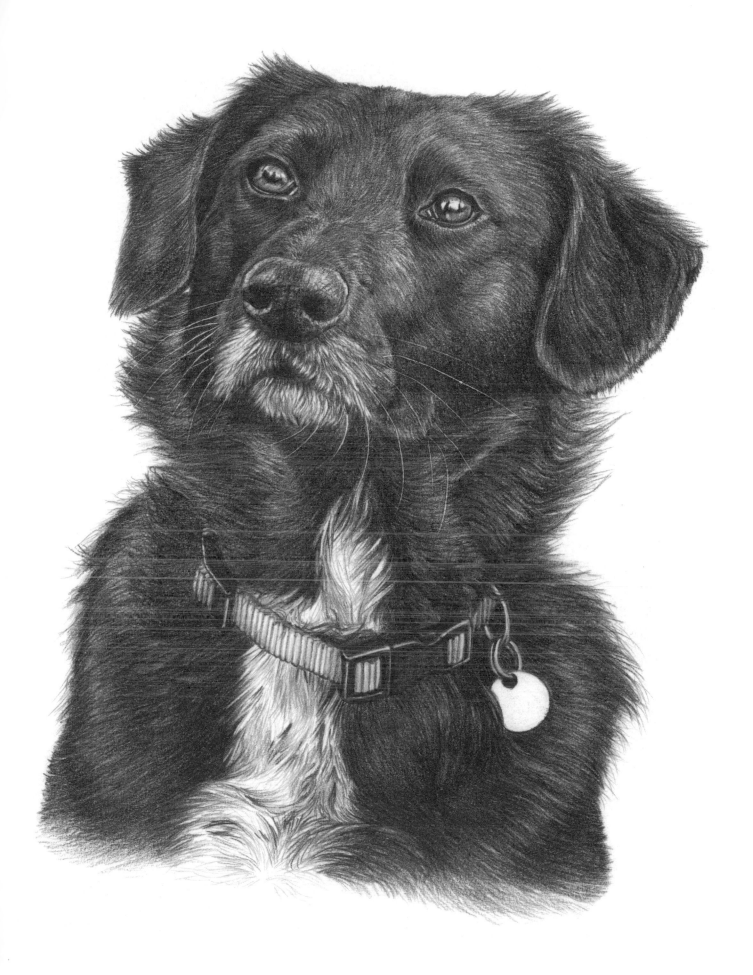

Cats

Body shapes

When it comes to feline body shapes there are really only a few 'cat'egories (pardon the pun). Most cats fall into one of three basic shapes: the typical non-pedigree varieties, the rather heavy-set Persian type and the tall, slim Siamese. Of course there are variations but these are the most common.

Heavy-set

This cat has long hair, thick legs, wide body, a large head and a heavily-plumed tail – all typical characteristics of the Persian body type. There is often a large ruff of fur around the neck, particularly on this particular breed type (the Blue Smoke). The cat is typically blue-grey all over with the head and body being darker than the rest. Some have faces so flat there is almost no profile at all, but this illustration is of a cat with a less extreme face shape.

Slim

Siamese cats are one of the most vocal breeds I have ever come across! They are very elegant and agile but are not everyone's cup of tea. Their body shape is typically tall, very slim with long legs and an almost triangular head. The eyes are often a piercing blue, and like the ears are quite large in proportion to the head.

Typical

This type of cat can vary quite considerably in colour and fur length due to the breeding being unregulated. The illustration shows a white cat. The body shape is generally slim, very commonly short-haired, slim-legged and not as stocky as the pedigree. There are long-haired varieties of the non-pedigree too but the most popular type seems to be the short-haired black cat, of which there seems to be an abundance!

Eyes

All domestic cats have slit shaped pupils (unlike most big cats), though the pupils appear very full and round in the dark. The shape of the face and eyelid affects the outer appearance of the eye, as illustrated below.

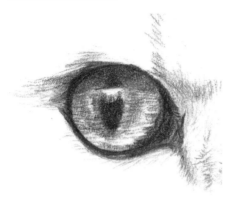

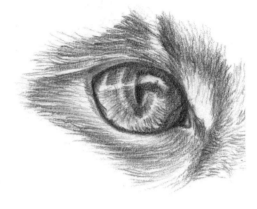

Persian

Whether they be of a Persian cat or a British Blue Shorthair, this type of cat always has eyes that appear round and quite large.

Siamese

The eyes of a Siamese cat are almond-shaped and very pretty. They are quite easily recognisable as they have a slanted eyebrow, making them point up at the corner.

Non-pedigree

The eyes of the non-pedigree (affectionately termed 'moggy') cat can vary, especially if the individual is made up of a mix of another pedigree. This eye illustration shows the shape of a basic non-pedigree cat such as the example on page 65. The eye is rounder than the Siamese but with no slant to the eyebrow.

Head shapes

As with the typical body shapes illustrated earlier, the most familiar head shapes of cats are the pedigree Persian or Exotic Shorthair, the Siamese and the different types of non-pedigree cat.

Exotic Shorthair

It is quite apparent that the face shapes of the Exotic Shorthair and even that of the Persian Longhair are very round. Both types of cat have matching circular eyes, short rounded ears and the profiles of their faces are very flat as the noses hardly protrude at all.

The cheeks are quite full and the mouth tends to look downturned, giving them a slightly sad expression.

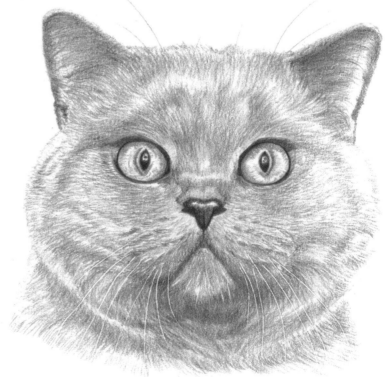

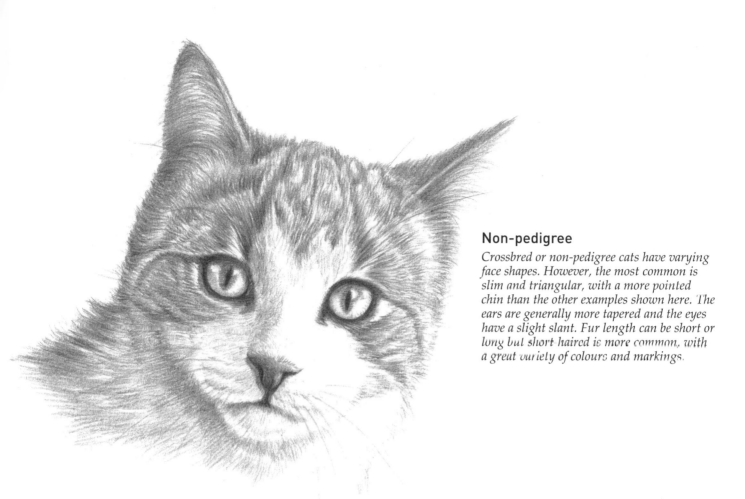

Non-pedigree

Crossbred or non-pedigree cats have varying face shapes. However, the most common is slim and triangular, with a more pointed chin than the other examples shown here. The ears are generally more tapered and the eyes have a slight slant. Fur length can be short or long but short-haired is more common, with a great variety of colours and markings.

Siamese

The Siamese cat also has a triangular face shape which is very lean and angular. They usually wear a very aloof expression and their eyes are a very distinctive shape and colour. The ears and nose are quite dominant in this breed, making them appear very striking: there is no mistaking a Siamese when you see one!

The profile of the face is the total opposite of the Exotic Shorthair on the facing page, with the angles of the face making it protrude quite prominently when viewed side-on.

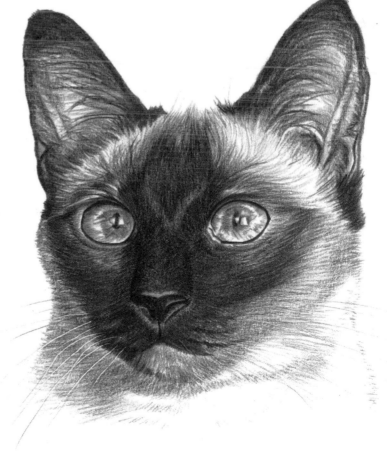

Tom

There are all sorts of cat I could have used for this project but I wanted to use a shorthair to demonstrate the shape of the eyes and face fully and clearly. This particular cat is owned by a lady who runs a well-known cat rescue centre and he was a rescue himself. He is a young ginger tomcat, full of energy and extremely inquisitive. I just managed to capture this photograph of him before he shot off on yet another adventure...

MATERIALS

Smooth white card, 30 x 42cm (11¾ x 16½in)

4H, 2H, 3B and 5B graphite pencils

Pencil sharpener

Putty eraser

Rough paper

Embroidery tool or knitting needle

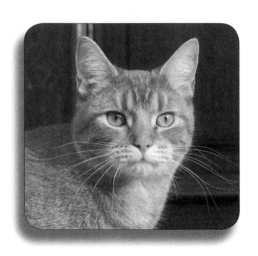

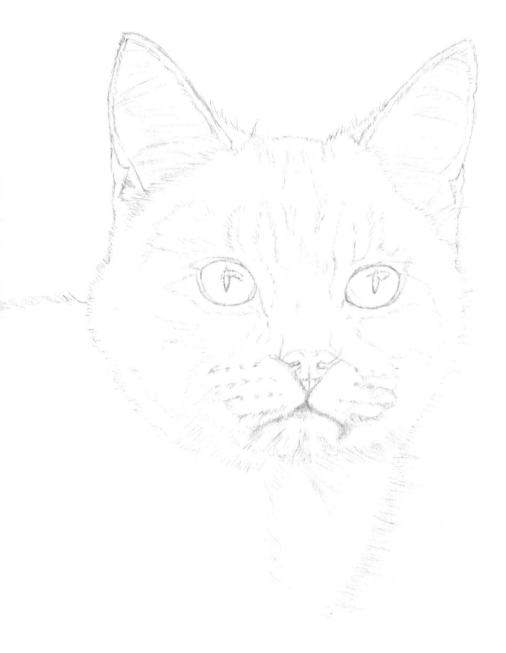

/ Outline Draw the outline using your chosen method of grid, tracing or freehand. This outline is drawn in the centre of a 42 x 30cm (16½ x 11¾in) piece of smooth white card with a 2H pencil and the drawing is around 30 x 21cm (11¾ x 8¼in) in size. Keep your pressure light when drawing this outline so that mistakes are easily erased and rectified. Remember to have a piece of rough paper ready to rest your hand on as you work to prevent smudging.

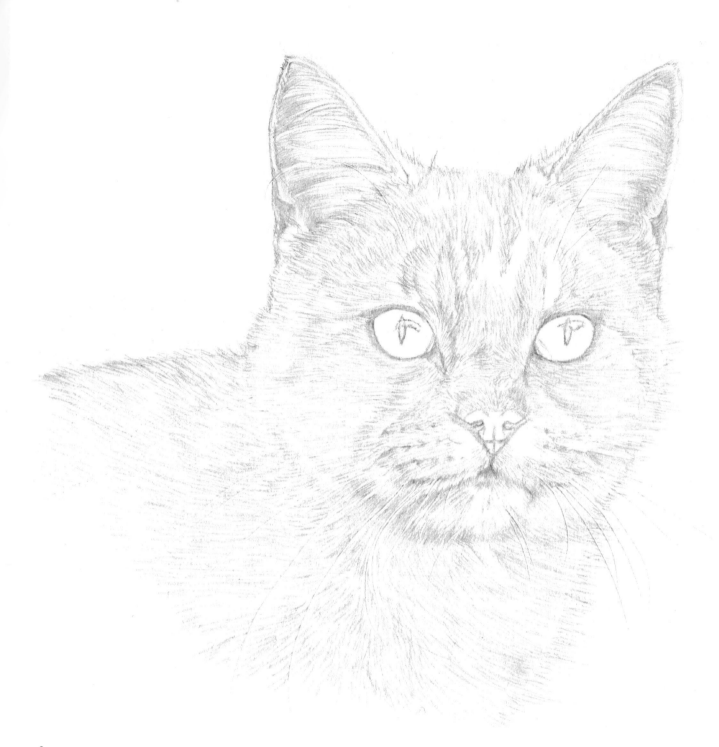

2 **Indenting whiskers** Before beginning to shade, use an embroidery tool or knitting needle to indent the cat's whiskers, starting from the root and working out to the tip. This stage is irreversible so make sure you know where each whisker is heading before you start from the root.

Fur Select a 4H pencil. Starting at the top of the head or between the eyes – my favourite starting point – begin to add a light layer of short fur. Make sure you follow the hair direction from your reference picture, as cat's facial hair can be complicated. When you get to the darker areas of fur, use the pencil more sparingly or it will repel the heavier grades of pencil later on when you try to darken further. Take care as you come to the indented hairs that the pencil tip does not slip into the indentations and fill them in. Keep the pencil marks lighter still when you come to the white sections of fur, concentrating more on adding the fur in the shadowed sections. Continue until your cat looks similar to the picture above.

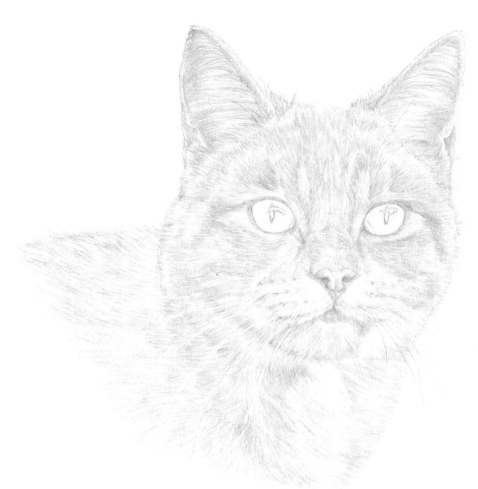

3 **Developing the fur** Use a 2H pencil with a fairly sharp tip to go back over the darkest areas of fur on the cat, all over from the tips of his ears down to the back of his neck. Keep your touch light, or you will fill up the tooth of the card, preventing you from adding the darker grades of pencil later.

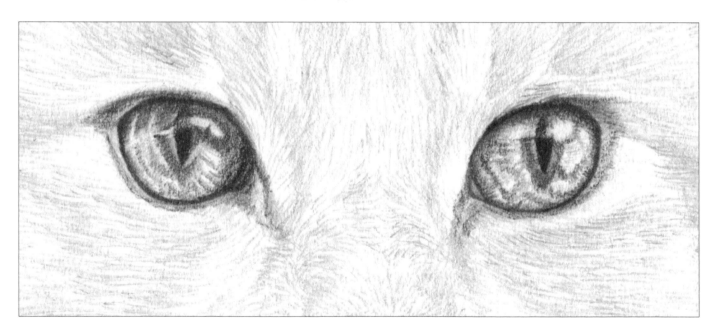

4 **Eyes** Begin by using the 2H pencil again and make sure that it has a reasonable point. Gently fill in the pupils, carefully working around the highlights in the eyes. Add the dark shading around the pupil and create all the lines and markings within the iris, keeping your touch light. Put in the shadows cast by the eyebrows and darken the corners of the eyes. Add another layer of 2H in all these areas again. Next, use a sharp 3B pencil and go back over all the same places again darkening further. Be careful though not to over-darken all the little markings within the iris. Finally, use a sharp 5B pencil to darken the pupils, the outline of the eyes and the shadows on the top of the eyes to complete the process.

5 **Tonal work** Now that the eyes are complete, select the 3B pencil and begin to darken the fur working from the ears down. Take care to work around and between the hairs in the ears. Continue down the cat's head remembering to leave some white spaces for the pale fur between the markings. Keep referring to the original photograph for the hair direction as you work. When you reach the eyes work carefully around them. Carry on down towards the nose and cheeks and keep going until you have covered the whole cat in 3B.

http://cli.gs/b2i1o41

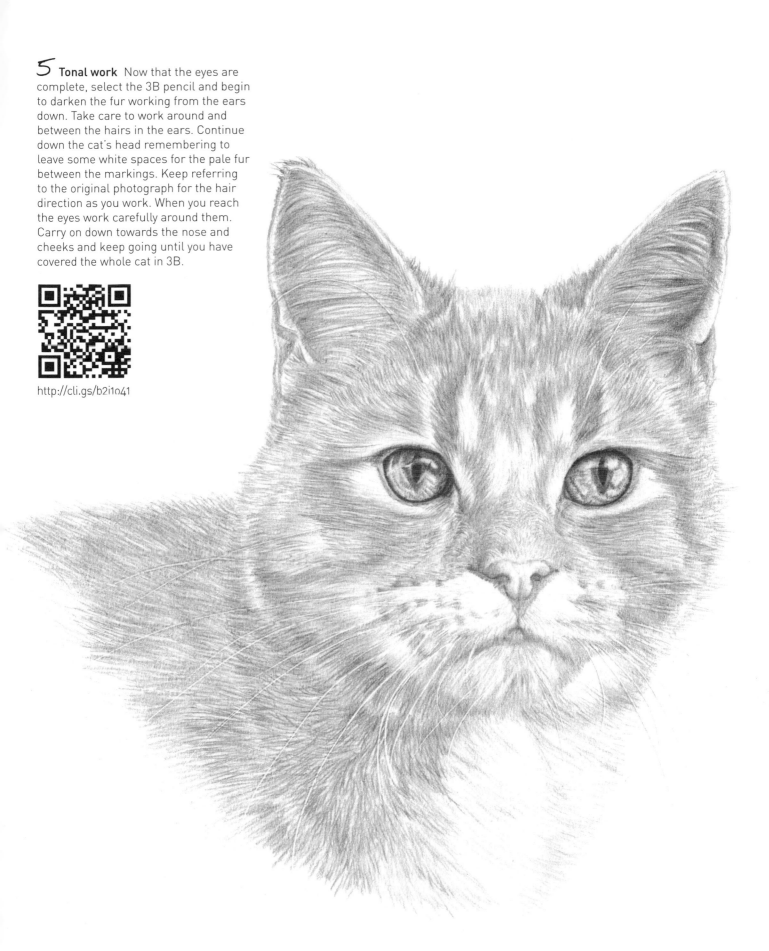

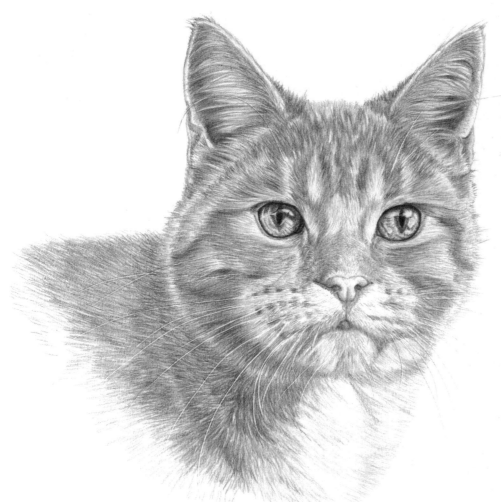

6 Adding depth Go back over the cat again with the 3B to add even more depth. Use a firmer hand and make sure your pencil has a good point. Do not forget the darkest markings go on the forehead and cheeks. Darken the cat's fur on his neck and back also. Add more 3B to the spaces between the hairs in the ears.

http://cli.gs/b2i1o41

7 Details Use the 2H pencil to add all the short light hairs in the lightest areas on the forehead, around the eyes and on the cat's cheeks. You will also need to use this pencil to create the roots of the whiskers as they flick out from the face and into the background.

Tip

This is quite fiddly to do. You may find it easier to turn your card upright to make drawing the whiskers in less difficult.

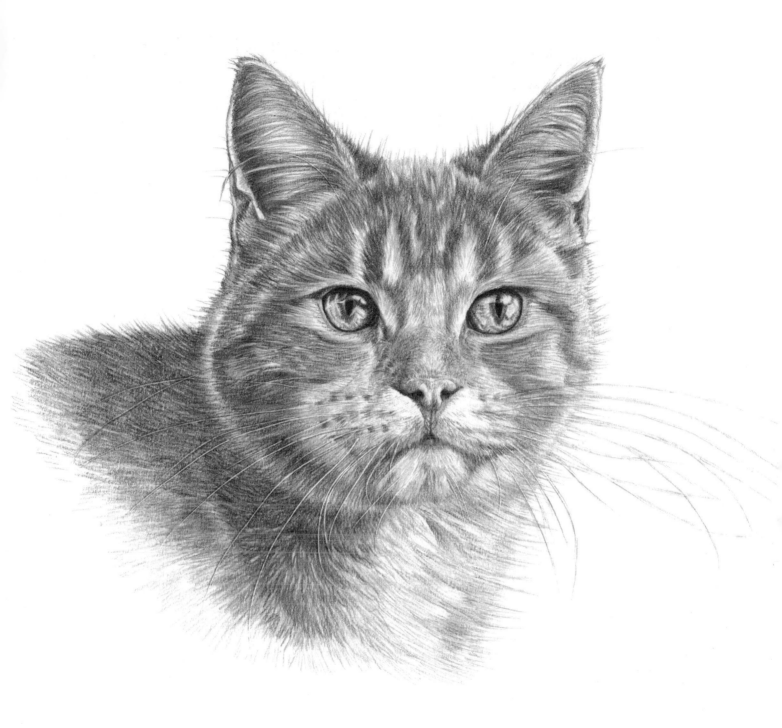

Tom

30 x 21cm (11¾ x 8¼in)

Graphite pencil on smooth card.

*At the final stage, use a sharp 5B pencil to darken all the markings gently, beginning
with the cat's head. Deepen the shading in the eyes if required, darken the nostrils
and the nose itself slightly and top up the shadow on the cat's back, behind his head.
Go back over his outline and flick out some wispy hairs to fluff him up and complete
the picture.*

Horses

There are many different breeds of horse and pony – far too many to cover in detail in this book. However, on these pages are a few of the more common and distinctive examples, which will help when it comes to drawing the head and body shapes of the various kinds of horse.

Head shapes

Thoroughbred

A very popular horse, the thoroughbred's head shape is long and lean with all elements in proportion. The ears are tall and slim, the eyes medium in size and shape and the face lean and muscular. The nose and nostrils are well defined and a deep mouth makes the appearance of this horse dependable and trustworthy.

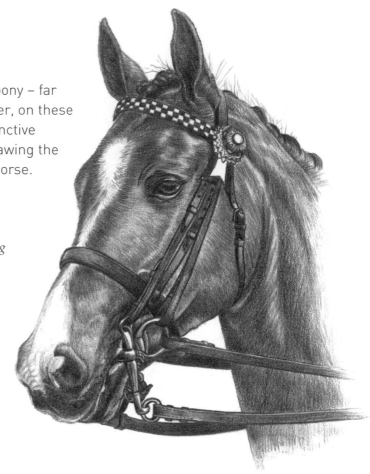

Arab

Arabs are known for their feisty temperament and flighty body movements, but no one can deny their beauty and grace. The head shape is very different from that of any other horse or pony breed. There is a strong dip in the profile between the eyes and the beginning of the nose which is extremely defined and singles this breed out as special. The eyes are large and the nostrils are wide and flared, giving the horse an edgy and highly strung appearance. They are my personal favourites.

Body shapes
Shetland pony

The Shetland pony has one of the more distinctive body shapes. The body is short in length and height, and the stocky legs complement the overall stout appearance of this pony. The head is always short and wide but the overall look of the pony is very appealing. Their fringes and manes are often long, and can grow to cover their eyes. Their tails can be so long it looks as though they could trip up on them! The coat length and colours can vary considerably from fine short hair to long and thick, and the colours from mushroom to black and white spotted.

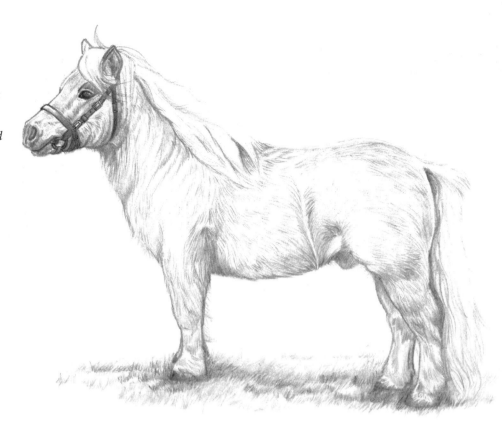

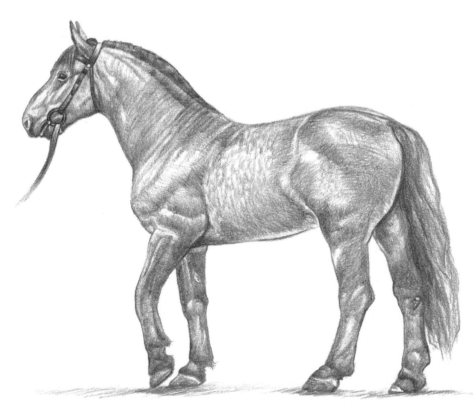

Welsh cob

Another interesting body shape is that of the Welsh cob. There are many variations on coats and colours but the basic body shape remains the same. The overall look is sturdy and muscular. The head is shorter than the thoroughbred's with a wide Roman nose. The muzzle is deep and strong and the head sits on a well-proportioned neck. The body length is neither short nor long but the legs are well-defined and thickset in order to carry the heavy body. There is a powerful and determined look to this breed and they are known for their stamina.

Dee

This study is of a breed of horse called the Irish Draught, which (as the name suggests) originates in Ireland. Speaking from experience I can say that they are very laid back, extremely intelligent and particularly people-orientated. As horses they are brilliant all-rounders, and can turn their hooves to hunting, jumping, eventing or even dressage – a bit like those people we all knew at school who were good at everything!

Originally a chariot horse, the Irish Draught evolved to become the perfect family horse. He was a farm horse during the week, took his master hunting on a Saturday and was fully capable of pulling the family trap to church on a Sunday.

The model in the photograph is my friend's horse, Dee. He has all the qualities I listed earlier and combines them with a quiet and calm beauty that is a special quality in a horse. I have a huge soft spot for him and I am sure you will too when you have finished his portrait.

MATERIALS

Smooth white card, 30 x 42cm (11¾ x 16½in)
2H, B, 3B and 4B graphite pencils
Pencil sharpener
Putty eraser
Rough paper

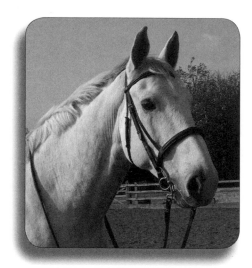

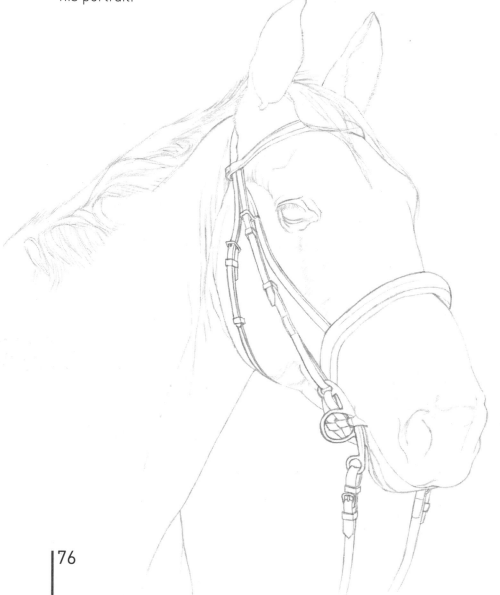

1 Outline First, draw the outline using your chosen method of grid, tracing or freehand. This outline is drawn in the centre of a 30 x 42cm (11¾ x 16½in) piece of smooth white card with a 2H pencil and the drawing is roughly 21 x 30cm (8¼ x 11¾in) in size. Keep your pressure light when drawing this outline so that mistakes are easily erased and rectified. Tuck a piece of scrap paper under your hand as you work to prevent smudging.

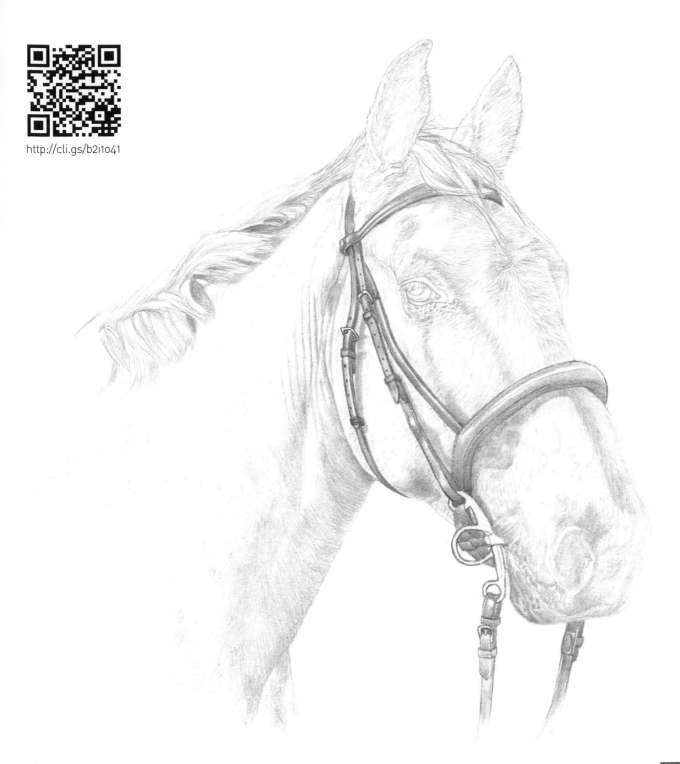

2 Ears and hair Gently put in the hairs in the inner ears and outer edges using soft strokes of a fairly sharp 2H pencil. Note how short the hair becomes on the horse's head compared with the insides of the ears. As you work on the horse, use your putty eraser to lighten the outline around the outside before you fill in each particular area. This is a light horse and you do not need a dark outline around the outside. As you work down the face, keep the hairs you can see very light and short.

Bridle shadows Add the shadows cast by the bridle as you work, shading in the same direction as the hairs underneath. If you add too much dark anywhere and the horse is looking too grey, simply shape your putty eraser, press it on to the area you wish to lighten and lift off, repeating until you have the desired effect. Unless you feel you have really overdone it, try to wait until you have added a darker grade of pencil so that you can be more objective before making any alterations.

Tip

To ensure a very light touch with your pencil, hold the pencil near the end furthest from the tip so that the pencil is almost horizontal in position. This makes applying too much pressure almost impossible.

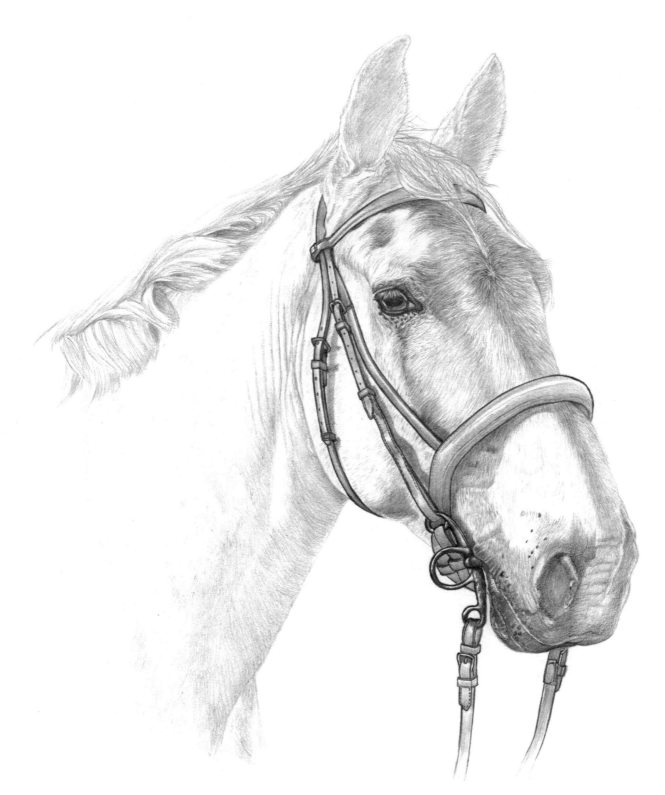

3 **Bridle** Use the 2H to add the base coat of shading to the bridle, leaving the highlights untouched. The texture for the bridle leather needs to be smooth and flat, apart from where the straps bend to go through the buckles. Go over the bridle at least twice with the 2H to darken further.

Eye Gently add some shading to the eye now. Create the eyelashes which overhang the eye and flick out slightly at the ends. The eyelashes are very important and as you work on the eye you must gently work around them to ensure they continue to stand out. Shape the putty eraser and use it again to pick out the lashes if you fill them in by mistake. Fill in the iris and outer eyelids. Draw in the hairs above the eyebrow and those under the eye also. Darken the inner ears further and add some more 2H to the mane and shadows underneath it.

http://cli.gs/b2i1o41

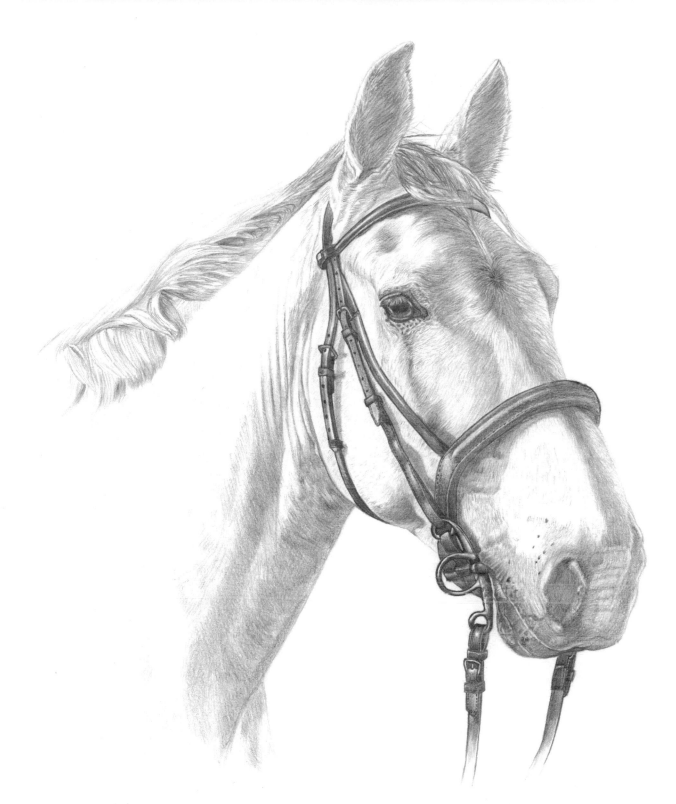

4 **Bridle and metalwork** Outline the bridle again, this time with a sharp B pencil, including all the metalwork. This will help contain your shading when you fill in the bridle leather again later with the B pencil. Use the 2H again to fill in any metal buckles and the clip and rings on the bit in his mouth.

Face Continue to shade down the horse's face with the B pencil, darkening the left side of the face (right of the picture) where the shadows are most prominent. Add more B to the 'star' shape in the centre of his forehead and deepen the shadows cast by the bridle as before. Begin to add more depth to the muzzle still using the pencil softly and building slowly layer by layer. Darken the inside of the nostril and consult your reference for the correct shape of the lips. Create more darks in the mane, fringe and in his ears.

http://cli.gs/b2i1o41

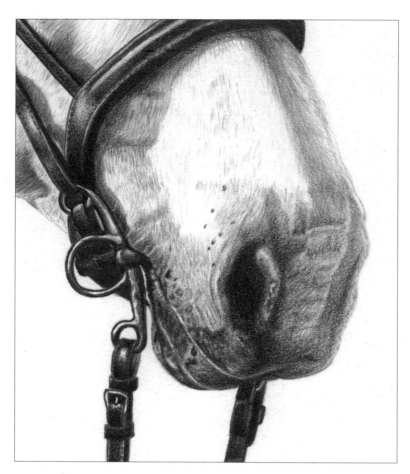

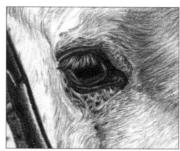

5 Details Fill in the bridle now. Work slowly to produce a smooth finish on the leather, pressing softly and layering until it becomes darker. Use the B now the point has worn down to top up all the shadows again and darken the shadow running the length of his face in the centre, so you can clearly see the divide between light and shade. Add some mottled shading to the underside of the neck and darken the shadows in the creases too. Add more shading to the pupil and iris.

Opposite
Dee

30 x 42cm (11¾ x 16½in)

Graphite pencil on smooth white card.

To finish the portrait, sharpen a 3B pencil and go back over the whole horse darkening the eye, forehead, muzzle, bridle, all shadows, mane and ears all over again. When the 3B seems unable to darken further, use a sharp 4B. Be selective with this pencil: as it is very soft and grainy, use it only for the darkest of darks. Suggested areas are the nostril, darkest edges of the bridle, inner ears, underside of the neck and a little on his lips. Lift off a layer or two of pencil with the putty eraser if you have gone too dark in places and whiten up any bright highlights. Touch up the eye area too, if required, and check the background for any smudges of pencil. Now congratulate yourself on a job well done!

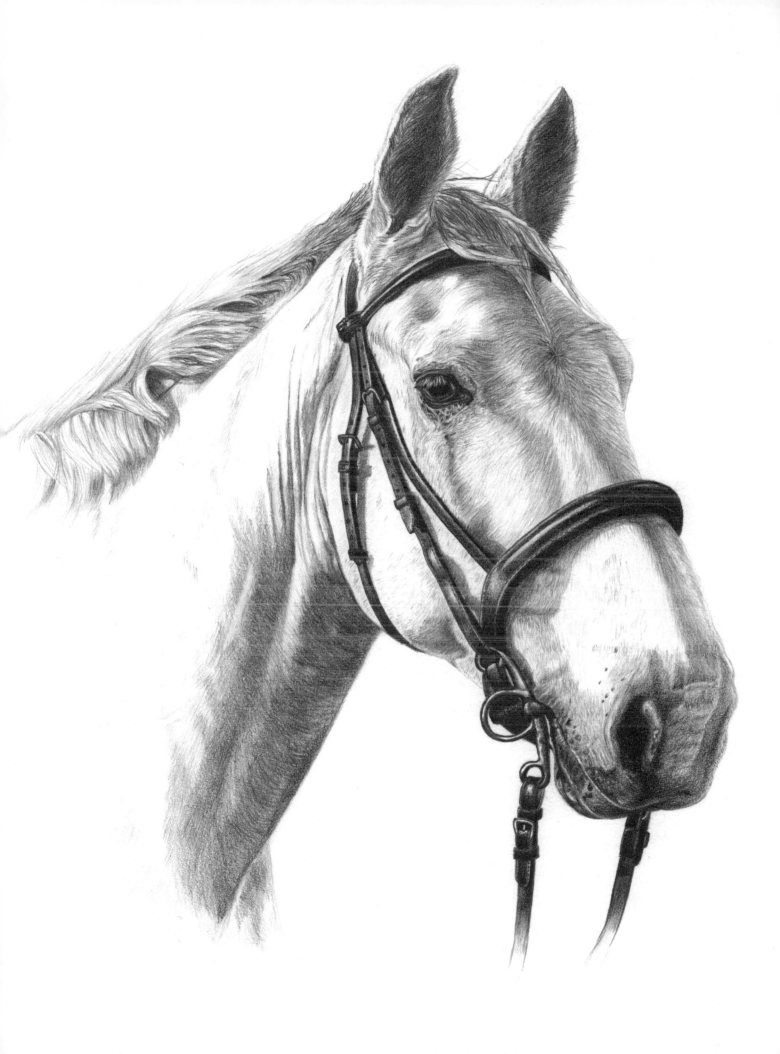

Foal: Jackpot

This compact little chap is a very young cob type foal, a type that you might recognise as a gypsy pony. We noticed him suddenly appear in a field that I passed every day on the school run and I became determined to track down his owner to get permission to take his photograph. Luckily one day when I was passing the owner happened to be there feeding him and he was very happy for me to take some shots in return for a copy of one of the photographs.

The more I studied the foal, the more I marvelled at mother nature for producing such a perfect baby. I found his muscle tone and compact mini-pony body just amazing and I knew he had to be a subject for the book. His name is Jackpot.

MATERIALS

Smooth white card, 30 x 42cm (11¾ x 16½in)

2H, B, 3B and 5B graphite pencils

Pencil sharpener

Putty eraser

Rough paper

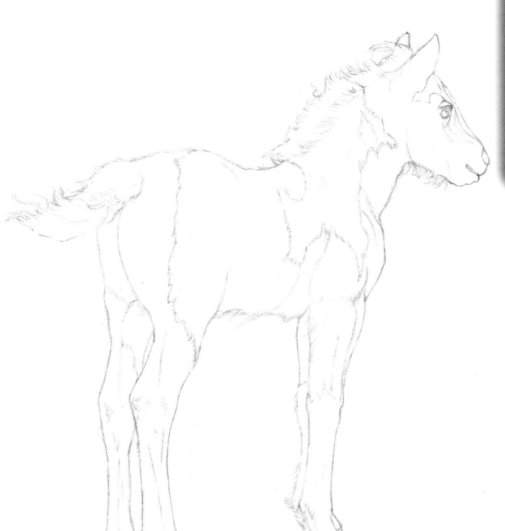

1 Outline Use your chosen method of grid, tracing or freehand to draw the outline. This outline is drawn in the centre of a 30 x 42cm (11¾ x 16½in) piece of smooth white card with a 2H pencil and the drawing is roughly 21 x 30cm (8¼ x 11¾in) in size. Keep your pressure light when drawing this outline so that mistakes are easily erased and rectified. Do not forget to have a piece of rough paper ready to rest your hand on as you work to prevent smudging.

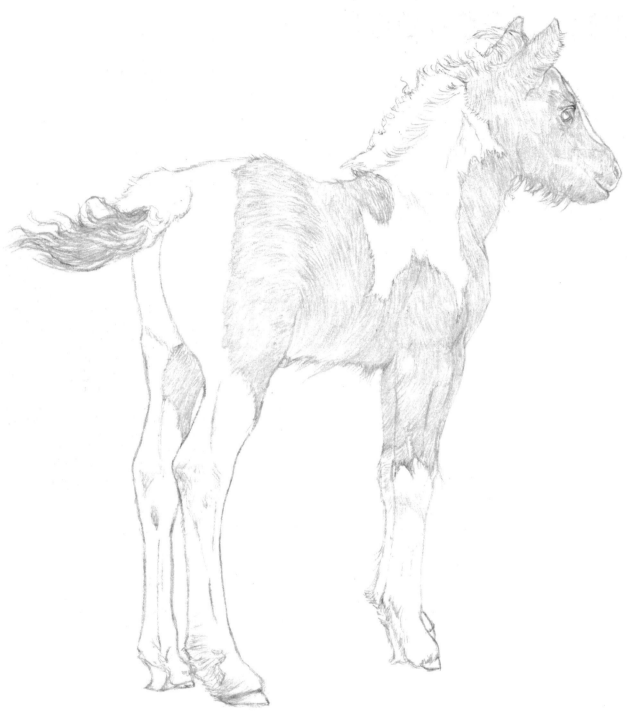

2 First layer Begin with a fairly sharp 2H pencil and work down from the foal's ears. Gently shade in the direction of the hairs (see the reference picture) and gradually cover the ears in a light layer of short hairs. When adding this first layer of 2H pencil to the outline, use the putty eraser to lift off the outline you created earlier as you move down and before you shade up to it, so that it is very faint. Continue to work down towards his face, noting where the hair changes direction. It is very important to get the hair direction correct even at this early stage, as this will be your guide for further layers of pencil. Continue working all over the foal's body, focussing mainly on the dark patches of his coat.

http://cli.gs/b2i1o41

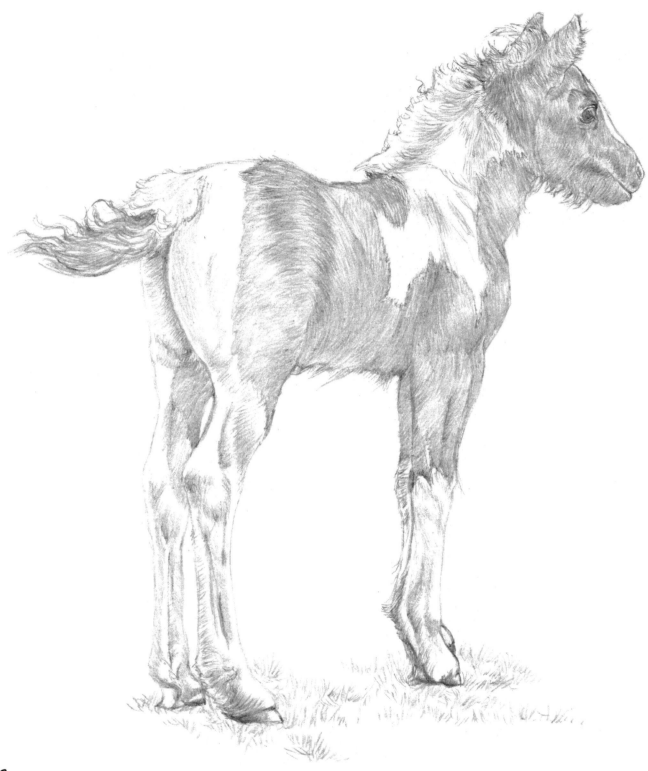

3 **Adding depth** Add another layer of the 2H all over the body in the dark patches again, using the technique described in step 2 but with a little more pressure. Accentuate the bone structure of his face by filling in the eye, taking care to leave some eyelashes over the top untouched for shading later. Begin to darken the foal a little more in the areas of shadow, but keep your pressure even: do not be tempted to press harder to get darker as this will not work. Depth is achieved only by layering slowly and methodically. Next, use the 2H to add the shadows within the white patches of the foal, taking care to work lightly. Work down the legs and darken the hooves. Add a smattering of short grass beneath the foal so that he is no longer floating in mid-air!

http://cli.gs/b2i1o41

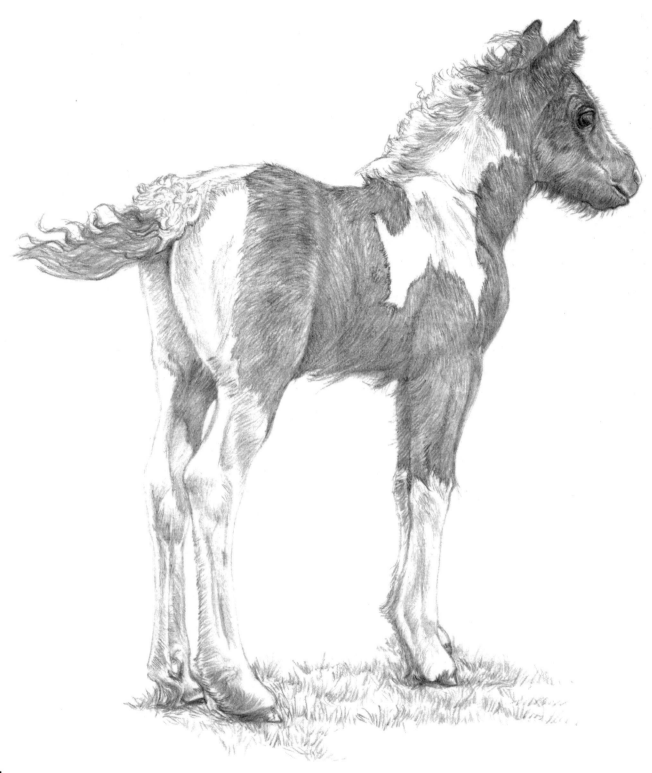

4 **Developing** Use a sharp B pencil now and starting with the ears begin to add more depth to the dark patches on the foal's coat. Spend some time getting his facial expression correct, as this will add to his youthful innocence. Shade in the shadows and hollows created by the bone structure and muscle tone under his skin. Darken his eye and mouth but do not press too hard. Work down his neck, making sure the hair direction is maintained. Build on the muscle shapes further in his shoulder and thigh and work down his legs to his hooves. Now the pencil tip is slightly blunt add some more shadows within his white patches, working from the mane down. Add some B to his tail and more depth to the grass.

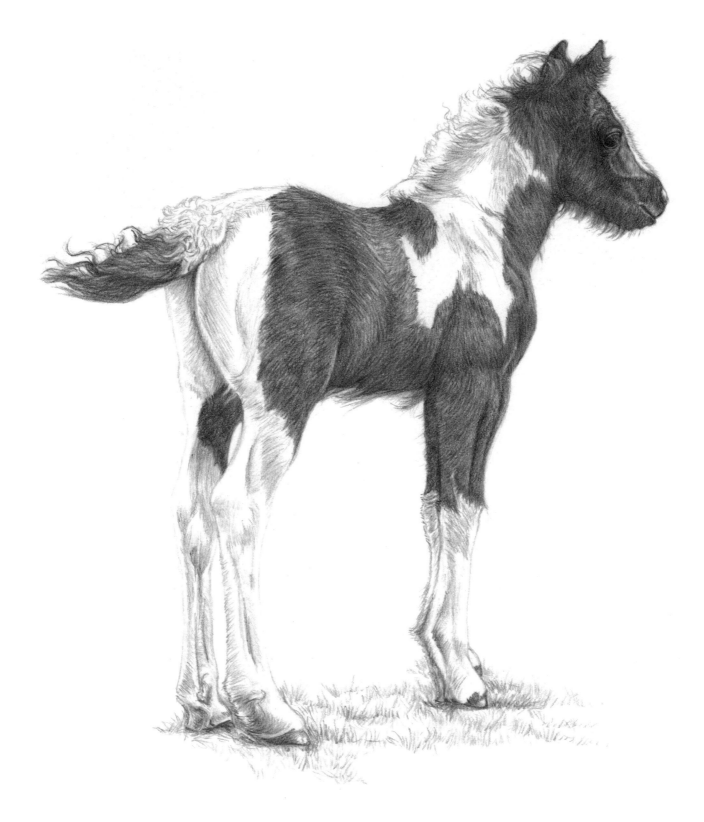

5 Darkening Sharpen a 3B pencil and go back over the foal's dark markings from head to hoof. Keep the pressure light as using it too firmly at this stage will result in dark lines which will be hard to erase. You will need a couple of layers to darken the foal satisfactorily. Be careful not to obliterate details you have already created around his face, as the 3B pencil is very soft and grainy. Darken the shadows in the white markings all over now. Add a little more depth to the grass.

http://cli.gs/b2i1o41

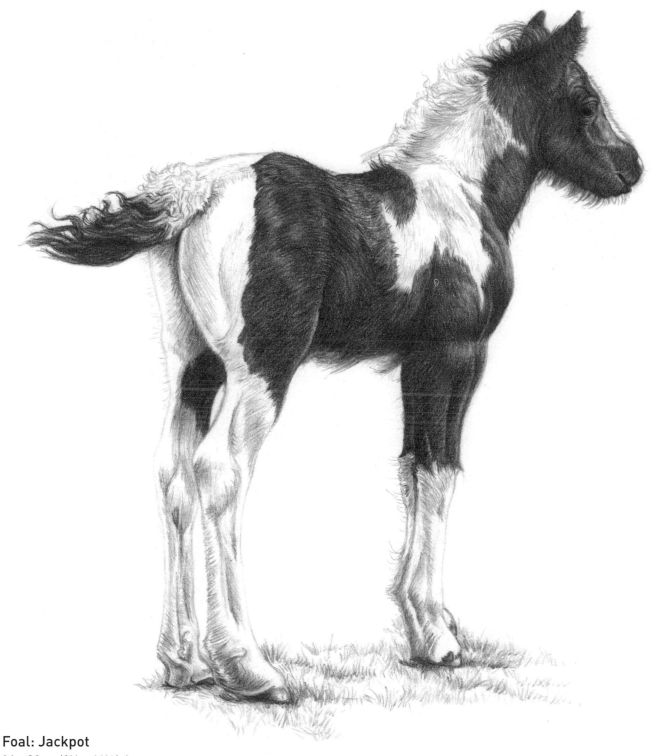

Foal: Jackpot

21 x 30cm (8¼ x 11¾in)

Graphite pencil on smooth white card.

To finish the portrait, use a sharp 5B pencil to darken the shadows all over to showcase his muscles and body shape effectively. Have a good look at the reference photograph from a distance to decide which areas require further work. Now use the 5B to accentuate the shadow behind his nearest ear and the side of his face and neck, gradually, not pressing too hard. Work down to his shoulder and chest, only shading the curves of the muscles. Next darken the black areas on the inside of his front legs and stomach. Deepen the shadow and shape of the thigh and hip joint and the dark hair on the inside of his rear left leg. Darken the shading a little within the white places on his legs slightly and add some 5B to his hooves. Finally, add more depth to the black parts of the tail and your little foal is complete!

Rabbit

It is highly likely that even someone not keen on rabbits would know what this breed of rabbit is called. There are four different types of lops: English, Holland, French and Mini Lop. The English and the French are larger breeds with the Holland being a dwarf variety. The Mini Lop weighs in at around 2.25kg (5lb), half the weight as the English and French lops.

Lops are a personal favourite of mine, maybe because they look so vulnerable with their floppy ears. As a breed, they are very friendly and affectionate and can become very attached to their owners. They also mix well with other pets in the household – even dogs – but only if introduced properly and supervised at all times!

MATERIALS

Smooth white card, 30 x 42cm (11¾ x 16½in)
2H, 4H, 2B, 3B, 5B and 6B graphite pencils
Pencil sharpener
Embroidery needle
Rough paper

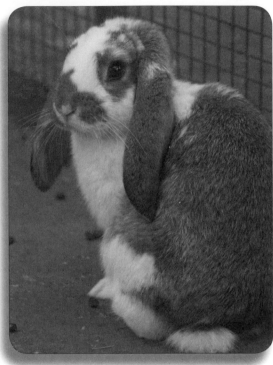

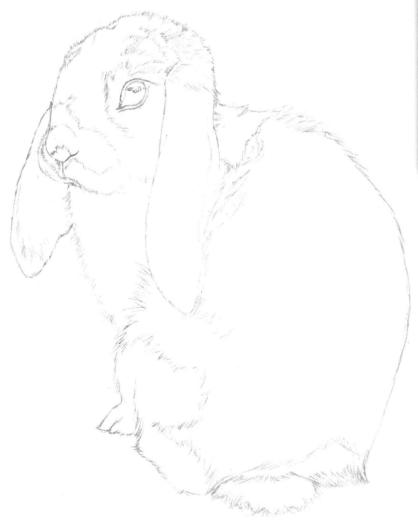

Outline Draw the outline using your chosen method of grid, tracing or freehand. This outline is drawn in the centre of a 30 x 42cm (11¾ x 16½in) piece of smooth white card with a 2H pencil and the drawing is around 21 x 30cm (8½ x 11¾in) in size. Keep the pressure light when drawing this outline so that mistakes are easily erased and rectified. Have a piece of rough paper close by, ready to rest your hand on as you work, in order to prevent smudging. Although a little of the back of this rabbit is missing from the photograph, I have simply followed the top line of his back and carried it on down and across to his tail.

Indenting Before you start shading, decide if you want to indent any hairs or whiskers. The key places are the white whiskers on the rabbit's cheeks, mouth and chin. Do this slowly and with precision as you can not undo these marks. Make sure your indenting tool is slim enough for the whiskers by practising on a spare piece of card. Use a 5B pencil to shade over them (crossways) to highlight the indentations you have made.

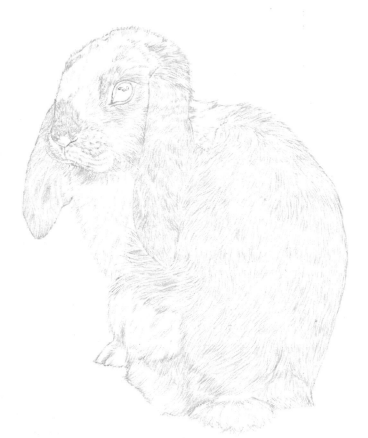

2 Once your outline is ready and with the indented whiskers in place, select a fairly sharp 4H pencil and add all the highlighted fur within the dark markings on the rabbit's face, ears and back. Begin at the top of the rabbit and work down. Next, use a 2H pencil to add some light shadows within the white fur under the chin, chest and on the rabbit's thigh and tail.

3 **Eye** The eye will establish the darkest tone for the portrait (see inset). Use the 2H pencil to shade in the iris, gently working around the highlights at the top of the eye. There is no pupil to be seen as the eye is too dark but the eye must still be darkest in the centre, with a slightly lighter section at the bottom where the light is entering the eye. After a couple of light layers of 2H, including shading the outer eyelid, sharpen a 3B and darken the same areas further, still working around the highlights in the iris. Again, after a couple of layers, use a 6B to darken it further. Lift off some of the graphite pencil to give more emphasis to the light at the bottom of the iris, if required. Shape the highlights, then use the 6B to darken the outer edge of the eye and corner of the eye too.

Fur Now use a fairly sharp 3B to begin to add the dark hairs around the whole eye. Use the 2H to darken some hairs within the white areas and then darken the dark patches of fur more using a sharp 5B pencil. Select a 3B pencil and darken the fur all over the rabbit starting again at the head and working down. Continue to work around the rabbit keeping a careful eye on the fur direction by studying the reference picture as you go. Use the flat edge of the 3B tip to add more shadows within the white fur on the head, back and chest, and not forgetting the thigh, feet and tail. Go back over the rabbit again from head to toe with the 3B, sharper this time and with a slightly firmer touch throughout. When you feel the pencil starting to skate a bit and darkening no further, stop immediately. You are now ready to use a 5B.

http://cli.gs/b2i1o41

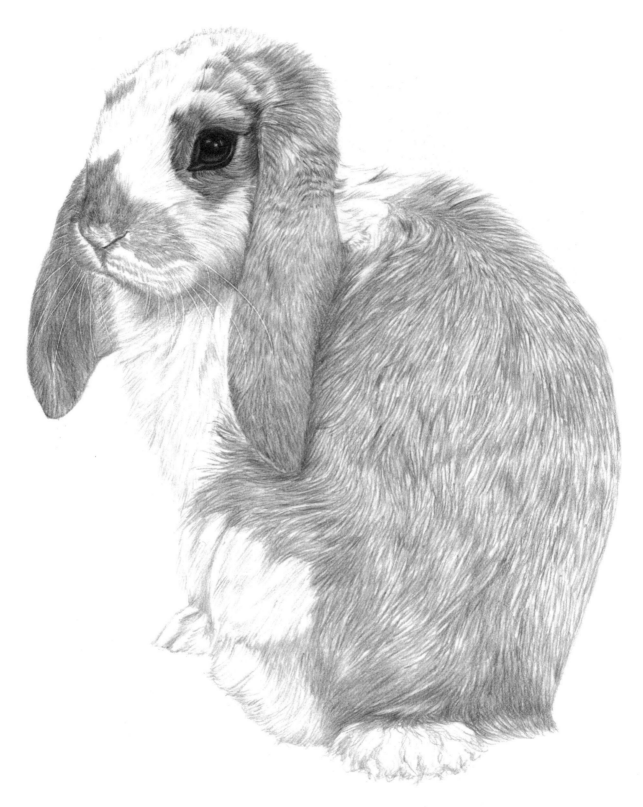

4 Sharpen a 5B pencil and starting with the head as before, work down building up the dark patches in the rabbit's fur. Continue to work down the face, emphasising the nose and the roots of the whiskers on his cheeks. Build up the shadow area under the rabbit's right ear and watch the whiskers begin to stand out more and more. Go back over the other ear too, keeping the pencil point sharp. Work steadily down the rabbit's back and towards his bottom and tail. Now you may need to repeat this complete step again if your rabbit is not as dark as the above but it really depends on how much pressure you used the first time with the 5B.

http://cli.gs/b2i1o41

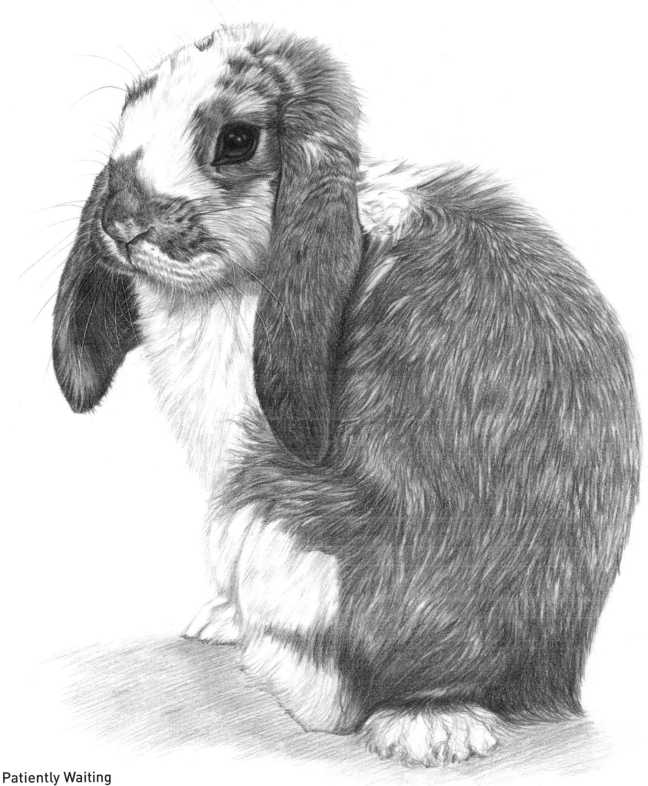

Patiently Waiting

21 x 30cm (8¼ x 11¾in)

Graphite pencil on smooth white card.

At the final stage, deepen the shadows in the white fur using the 2B pencil, not forgetting the foot and tail as before. Use the 2H to add tips to the indented whiskers you added to his cheeks that have no ends to them, flicking them out into the background softly. For the dark whiskers on the rabbit use a sharp 3B pencil.

To create the shadow under the rabbit, start with a light layer of 4H, followed by 2H and then finally darken with 3B. Your rabbit is complete!

Bearded Dragon

Bearded dragons are native to Australia, where they live in rocky areas. They are great climbers and have quite flat bodies with almost triangular heads, and lots of raised points or horns along the side of their heads and bodies.

When they are upset they can blow out a flap of skin under their beard as a warning, and can also darken the colour of this area to almost black. However, they are generally a very laid-back species which makes them easy to approach in the wild. It is because of this docile personality that they are a popular pet, as children can handle them very easily. In captivity they can grow as long as 61cm (24in) when reared correctly and have a very fast growth rate of around 1cm (½in) a month.

MATERIALS

Smooth white card, 30 x 42cm (11¾ x 16½in)

2H, 3B and 5B graphite pencils

Putty eraser

Pencil sharpener

Rough paper

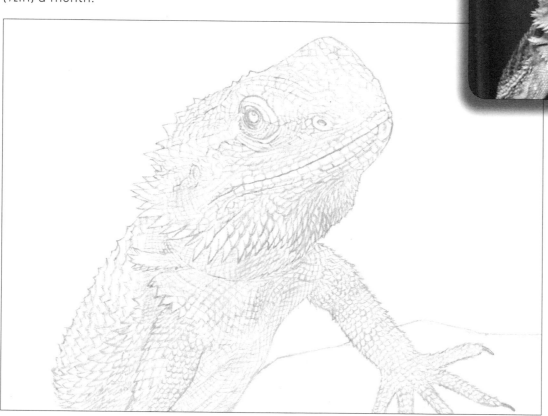

1 Outline Draw the outline with a 2H pencil, using your chosen method of grid, tracing or freehand. This drawing is around 30 x 21cm (11¾ x 8½in) in size, in the centre of a 30 x 42cm (11¾ x 16½in) piece of smooth white card. Do not forget to have a piece of rough paper ready to rest your hand on as you work to prevent smudging. Use a 2H pencil to complete the outline and detail. Unlike other subjects in this book, drawing the outline of the bearded dragon will take time and patience: you need to draw him completely at this stage, scales, horns and all! Spend some time simply studying the reference photograph before you start. This will help you totally understand all the shapes that make up his skin and how to create them. These shapes change from pointed horns to cone shapes and then again to diamond-shaped scales. As you complete the basic outline you will need to copy how the shapes change and follow the shape of his body too, at the same time.

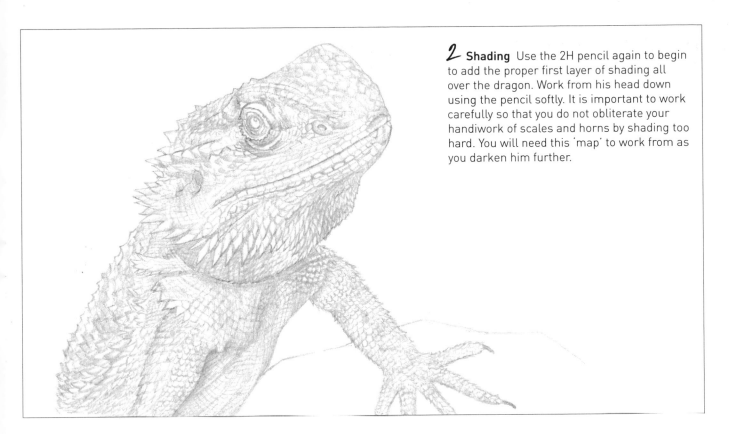

2 **Shading** Use the 2H pencil again to begin to add the proper first layer of shading all over the dragon. Work from his head down using the pencil softly. It is important to work carefully so that you do not obliterate your handiwork of scales and horns by shading too hard. You will need this 'map' to work from as you darken him further.

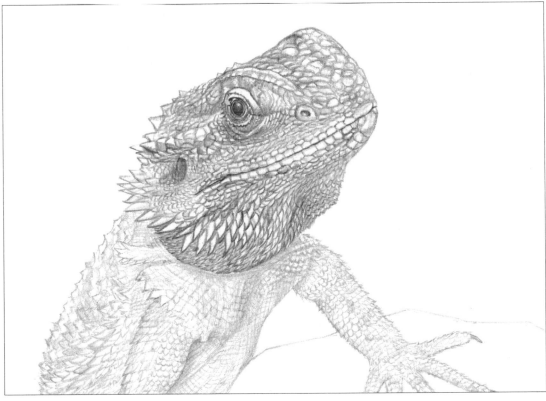

3 **Head** Use a sharp 3B pencil to darken the shading further on the head. As you work, update the outlines of the scales/horns. Take this first stage slowly as it is confusing and you can easily get lost. Darken the line of his mouth while the pencil is still sharp, as you can use this area to help gauge where you are if you lose your way. When you get down to the rock on which he is resting you will need some reference to work from. This part will be completed later.

4 **Scales** Once you have been all over him completely with one layer of the 3B, you can begin to use the same pencil to add some of the darker sections of horns on his back. Ensure the pencil is sharp as you work. Use this pencil also to make the cone shapes on his sides stand out more too with some undershading and darker outlining. The top of his head between his eyes is very snakelike but the texture is similar to that of smooth pebbles.

Rock To complete the rock simply find some reference – copy a rock from life or find a photograph to help you with the texture. Next, use the 2H to add this texture to the rock he is leaning on. Keep this light for now. When you have completed this, your picture should resemble the image below.

http://cli.gs/b2i1o41

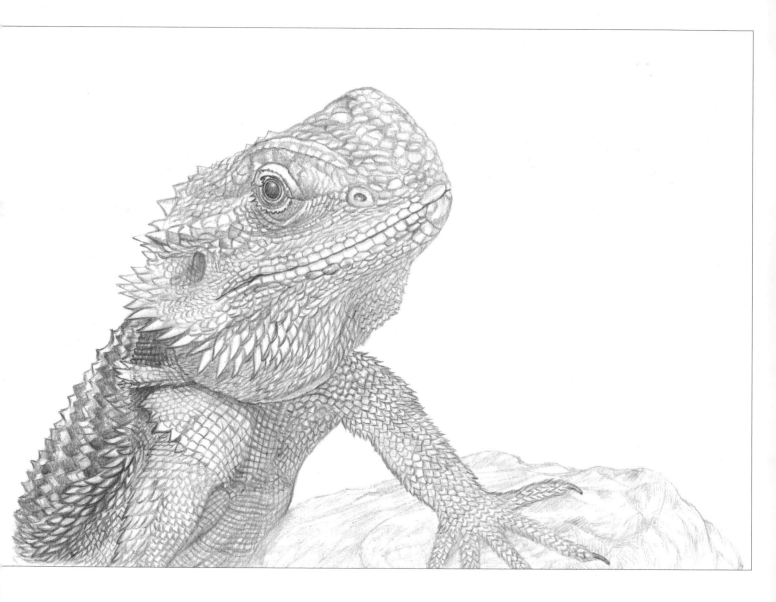

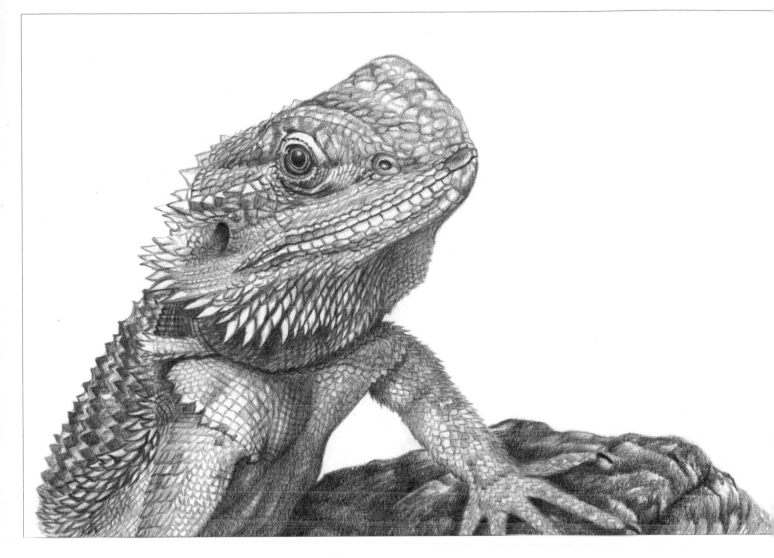

Brian's Beardie

30 x 21cm (11¾ x 8½in)

Graphite pencil on smooth white card.

At the final stage, use a sharp 3B to add some shadows in all of the areas required, this being on his belly, under his beard and chin, under his arms and any other dark areas including his nostril and ear (the hole on the side of his head). Darken his eye and the surrounding area too. As before, try not to obliterate too much of the pattern of scales and ridges you have previously created whilst you are shading. You can use the putty eraser to lift out sections where you may have shaded too much. Still using the 3B, darken the rock further, creating the darkest section where he is casting a shadow on to the rock itself.

Finally, sharpen a 5B pencil and use it to add even more depth all over the dragon and rock until they resemble the above picture. Congratulations on having the patience to reach the end!

http://cli.gs/b2i1o41

Index

Winter

Nicola Baxter

Illustrated by Kim Woolley

W

FRANKLIN WATTS
LONDON • SYDNEY

During the autumn the days grow shorter and the weather gets colder.
Slowly winter arrives.

Now try this
Do you think the photograph on the next page was taken in the autumn or the winter?
Can you be really sure?

3

The winter sun is not very hot.
We need to wear warm clothes
when it is cold outside.

Now try this

Some people put their summer clothes away when the
weather gets colder. Which of these clothes might
you wear in the winter?

4

Running and playing keeps you warm too. But you can tell that it is cold if your breath makes little clouds in front of your face.

Try this later
On a cold day, blow on to the window pane.
The cold glass will turn your breath
into tiny drops of water.
The same thing happens to your breath
in the air outdoors on a very cold day.

7

Sometimes it is so cold outside that water freezes and turns into ice. Putting grit or salt on roads and paths helps to stop people sliding.

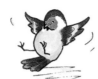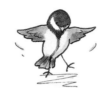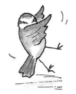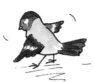

When it is cold, rain is frozen
as it falls from the clouds.
It may fall as little lumps of ice,
called hail, or as snowflakes.

Try this later

Under a microscope, all snowflakes have
six sides and each one is different.
Draw round a plate on white paper
and cut out the circle.
Ask a grown-up to help you follow these
steps to make your own snowflake.

When you have been outside
in the cold, hot food and drinks
taste good and warm you up.

Farmers need to feed their animals extra food to keep them going through the winter.

At winter celebrations, candles and lights cheer up the cold, dark days and remind people that the winter can be a time of new beginnings too.

19

For many people, the beginning of a new year is celebrated in the winter.

Try this later
Ask a grown-up to help you make
a calendar of the year.
Draw or cut out pictures for each month
and be sure to mark the times that
are special to you each year.

Winter seems to last a long time.
But even before winter is over,
the first signs of spring can be seen.

Index

This edition 2004
Franklin Watts
96 Leonard Street
London EC2A 4XD

Franklin Watts Australia
45-51 Huntley Street
Alexandria NSW 2015

Copyright © Franklin Watts 1996

Editor: Sarah Ridley
Designer: Kirstie Billingham
Picture researcher: Sarah Moule

ISBN: 0 7496 5227 6

Dewey Decimal Classification
Number: 574.5

Acknowledgements:
The publishers would like to thank
Carol Olivier and Kenmont Primary
School for their help with the cover
of this book.

Photographs: Bruce Coleman Ltd 11;
James Davis Travel Photography 13;
Robert Harding Picture Library 14,
17; Peter Millard cover;
NHPA 5, 7, 23; Oxford Scientific
Films / Animals Animals 9;
Trip 3; ZEFA 16, 21.

Printed in Malaysia